NORTHAMPTON

THROUGH TIME

David Humphreys &
Douglas Goddard

AMBERLEY PUBLISHING

To our family and friends, and all who cherish our local heritage

First published 2013

Amberley Publishing
The Hill, Stroud, Gloucestershire, GL5 4EP
www.amberley-books.com

Copyright © David Humphreys & Douglas Goddard, 2013

The right of David Humphreys & Douglas Goddard to be
identified as the Author of this work has been asserted in
accordance with the Copyrights, Designs and Patents Act
1988.

ISBN 978 1 4456 1656 8 (print)
ISBN 978 1 4456 1675 9 (ebook)

British Library Cataloguing in Publication Data.
A catalogue record for this book is available from the
British Library.

Typesetting by Amberley Publishing.
Printed in Great Britain.

Introduction

Northampton was founded in Anglo-Saxon times. Sailing up the River Nene from the Wash, the invaders could travel no further as the valley became much narrower, providing a good crossing point. A small hillock, now the site of St Peter's church and well above flood level, was chosen as a place of settlement, and a village called *Hamtune* (home village) arose. The Domesday Book tells us that after the Norman Conquest the town grew rapidly and by 1086 there were 300 houses. A powerful baron, Simon de Senlis, fortified it with massive stone walls and a great castle. He founded the Church of the Holy Sepulchre and St Andrew's priory, and rebuilt All Saints' church. His son added Delapre Abbey and St Giles' church.

Northampton's central position in the country gave it a special significance in medieval times. It was halfway between Winchester, the old capital of Wessex, and York, the chief town of Northumbria. It was not too far from London and was better placed than the latter for the King to deal with rebellion. Parliament was held in the castle on a number of occasions and in 1170 it was the location of the trial of Thomas Becket. In 1189, Richard I granted Northampton its first charter. Another royal connection survives in the Queen Eleanor Cross, erected by Edward I, in memory of his wife, who died at Harby in Nottinghamshire in 1290. Her body rested at Delapre Abbey on its way south for burial at Westminster Abbey.

Surviving street names, including the Drapery, Sheep Street, Horsemarket, Marefair, Mercer's Row, Tanner Street, and Gold and Silver Streets, show the flourishing trades and markets that grew up in the town, a trading centre for the surrounding villages. All Saints' church was used for market fairs before the Market Square was established. By the fourteenth century, England was much more settled politically and, as a result, Northampton's central position was no longer as important and it was superseded by London. From this

point, it remained a small market town until the nineteenth century. Nevertheless, a crucial battle of the Wars of the Roses was fought in the fields of Delapre Abbey in 1460.

The boot and shoe industry became the staple trade of the town in the sixteenth century, and during the Civil War, 40,000 pairs of boots were supplied to Cromwell's armies. This support of the Puritans prompted Charles II to order the destruction of the town walls and the partial demolition of the castle, during the Restoration. Little remains of the medieval town today, as the Great Fire of 20 September 1675 destroyed most of the area within the old town walls. King Charles atoned for his previous actions by providing 1,000 tons of timber to rebuild All Saints' church and his statue, dressed in a Roman toga, can still be seen over the front portico.

During the second half of the nineteenth century, mechanisation came to the shoe industry and instigated the building of a number of factories, particularly between the Mounts and the racecourse, where rows of terraced houses sprang up alongside them to accommodate the huge influx of workers. Between 1871 and 1900, the population of Northampton more than doubled from 41,000 to 87,000. The town boasted three railway stations, but was not connected to the main line from London to Birmingham until 1881 when the enlargement of Castle station heralded the final removal of the ruins of the once proud castle.

The twentieth century brought further expansion as new industries arrived and outlying villages were gradually absorbed into the borough boundaries. In 1968, Northampton was designated a 'New Town' to accommodate London overspill, so population doubled again and the Northampton Development Corporation managed the massive development of the town to the east. Avon Cosmetics, Carlsberg and Barclaycard set up headquarters in the town and ring roads were built to deal with increased traffic. The old shoe industry had now declined, as cheaper hides were imported from abroad and synthetic materials were used for footwear.

The population of the town had increased to 212,000 by the 2012 census, and jobs in industry have been replaced by public administration, financial services and distribution. Development will continue apace in the near future as the Greyfriars bus station is replaced, the railway station modernised and upgraded, and the town centre regenerated. The Northampton Waterside Enterprise Zone will create commerce and industry along 120 hectares of disused land close to Northampton's riverside. A new era beckons.

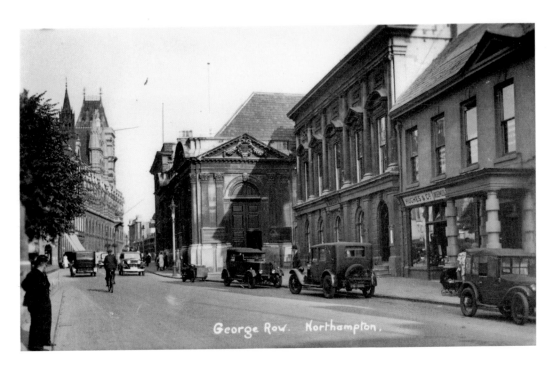

George Row

The Sessions House, built after the Great Fire of 1675, County Hall and the nineteenth-century Guildhall dominate this view from outside the old George Hotel. Northampton's original infirmary was in a house here from 1743 to 1793, and its entrance porch remains on the right. Taxis are parked outside to take passengers from the town centre. Today it is part of a one-way system. The Guildhall is shown currently undergoing restoration. A new courthouse was opened in Lady's Lane in 1993.

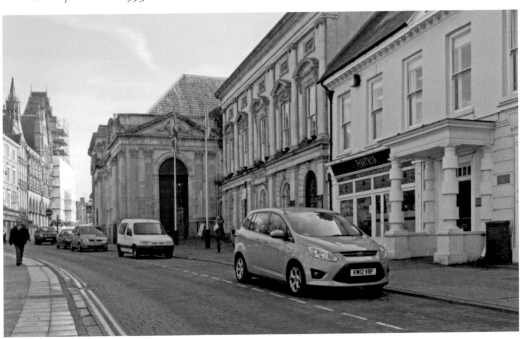

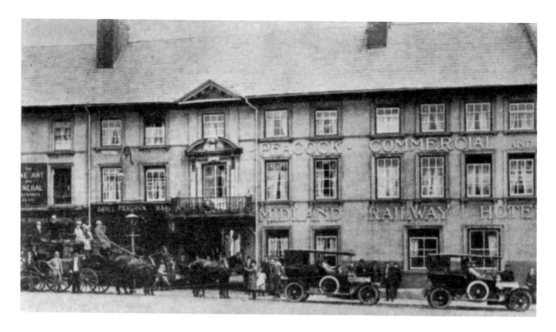

Proud as a Peacock

Prominent on the east side of the Market Square was the Peacock Hotel. Originally built in 1456 as an inn, it was rebuilt after the Great Fire of 1675 and in 1761 had stables for sixty horses. In the nineteenth century, politicians spoke from the balcony over the entrance and carriages can be seen awaiting passengers for the railway station or local race meetings. It was demolished in 1959/60. Initially, the modern shopping centre (Peacock Place) used the hotel's name but it is now called Market Walk.

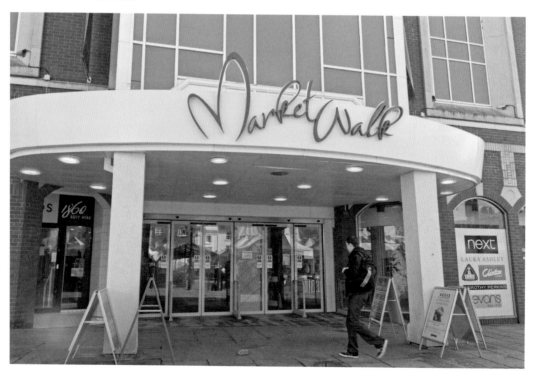

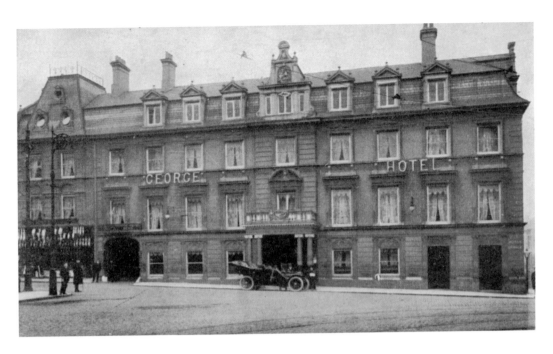

The George Hotel

The George Hotel was also rebuilt after the Great Fire. Its rooms had names like the Queen's Head Chamber, the King's Head, Mermaid and Mitre, instead of conventional numbers. It was well known for cockfighting and political speeches were made from the balcony over the porch. In the nineteenth century it was the last building to be disposed of by the tontine system. The current owners, Lloyds Bank, took it over in the 1920s. The space in front of All Saints' church is now enclosed to create a piazza.

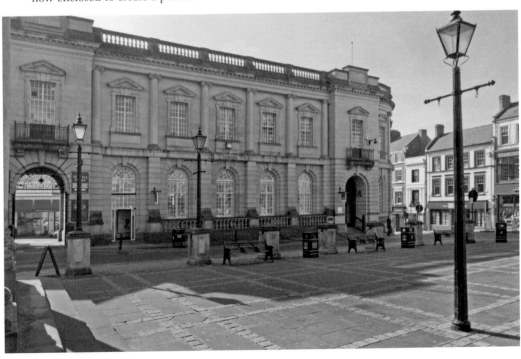

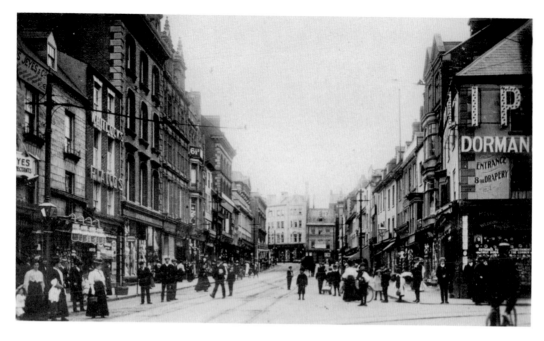

The Drapery from the South

The Drapery is recorded from 1483, but the name only referred to the west side. The east side, where glove makers worked, was called the Glovery. The corner with Mercer's Row, now the Nationwide, was occupied by Dorman & Pope, wine merchants. Opposite was the traditional chemist's of Philadelphus Jeyes, established in 1810 and well known to locals. Some of the High Street banks have their offices here and have replaced some of the shops. Below, the Northampton Pipe Band leads the Remembrance Day parade from the Market Square to All Saints' church in 2010.

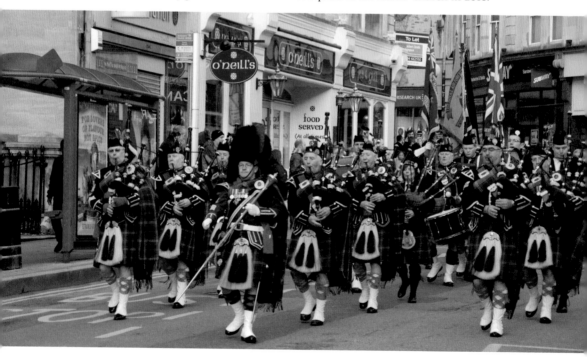

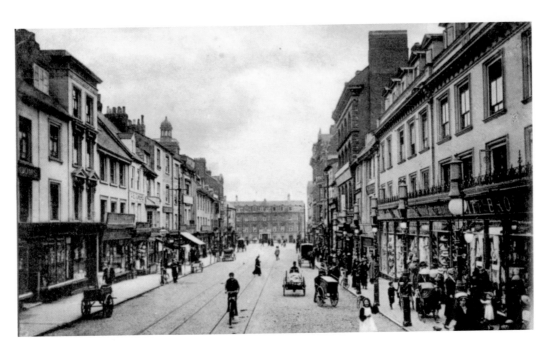

The Drapery from the North

On this postcard of 1912, the Drapery is shown from the north, and at the far end the George Hotel still dominates the scene, and the dome of All Saints' church, rebuilt after the Great Fire of 1675, peeps over the skyline. On the right is Adnitt Bros who traded as high-quality draper's and ladies' outfitters, until the store was taken over by Debenhams. Throngs of shoppers still converge upon it, but the handcarts and bicycles have been replaced by buses and cars.

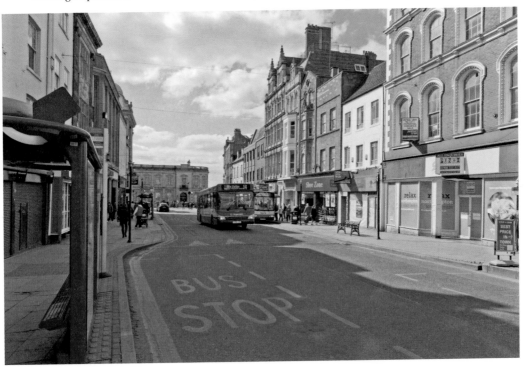

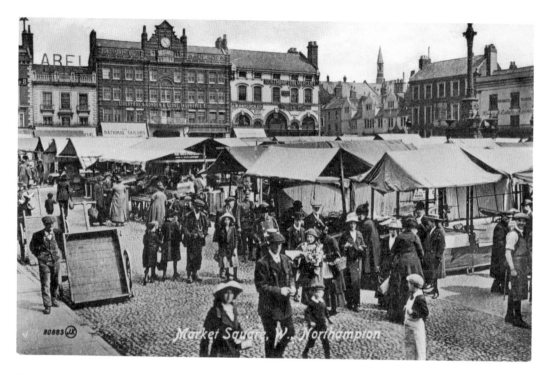

The Market Square in Edwardian Times

A busy Market Square in Edwardian times was overlooked by the imposing Emporium Arcade, which contained 150 businesses and 50 shops. Abel's traded as a music shop from 1817 to 1970. The office of the *Mercury and Echo*, which had merged in 1880, stood at the corner of Newland, a street that was replaced by the Grosvenor Centre. The modern façades are far less attractive. The fountain, erected in 1863 for the marriage of Prince Albert Edward to Princess Alexandra, was demolished in 1962.

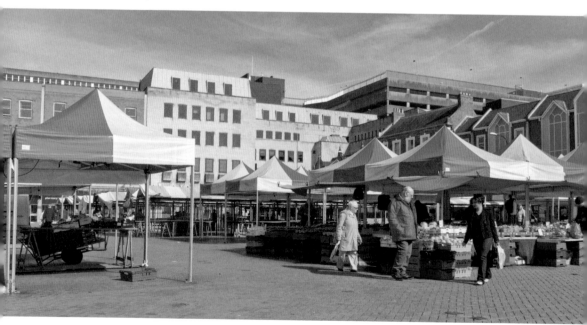

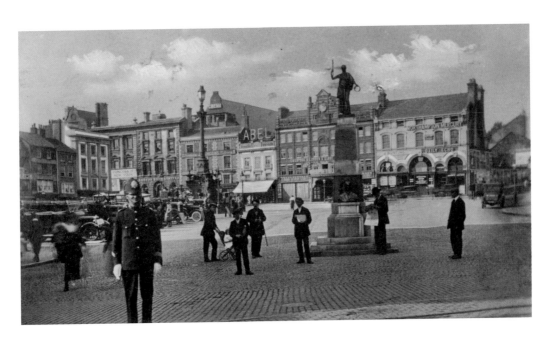

A Sportsman and a Soldier

Lt-Col. Edgar Mobbs, captain of the Saints' rugby football team, was capped seven times by England. He recruited his own battalion of sportsmen when the First World War broke out. He was killed at Ypres in 1917 and a memorial to him was erected on the Market Square. This was later deemed to be a traffic hazard and in 1937 it was removed to its present, much quieter location in the Garden of Rest.

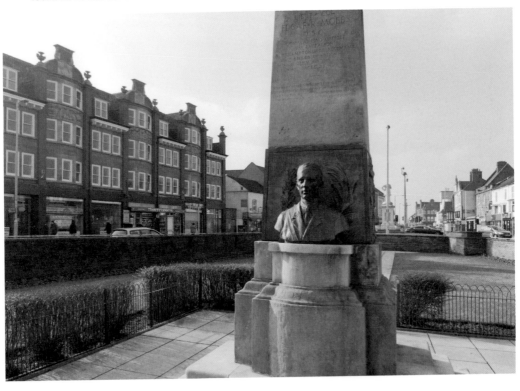

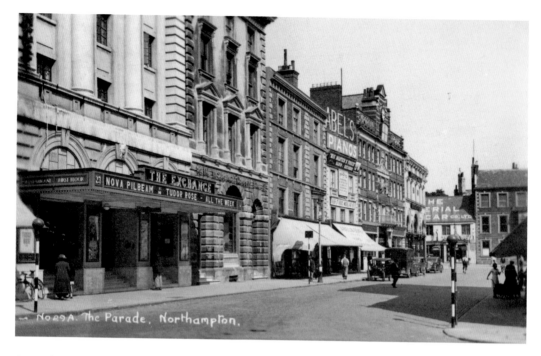

No 29A. The Parade. Northampton.

An Exchange of Uses

The Corn Exchange on the Parade was opened in 1851. It was converted from an exhibition and concert hall to the Exchange Cinema in 1920 and in 1929 showed the first talking picture, Al Jolson's *The Singing Fool*. This postcard was posted in 1937. The Exchange continued life as the Gaumont and then the Odeon before ending up as a bingo hall, and is now one of the town centre's bars and clubs. The access road and the street of Newland have now gone.

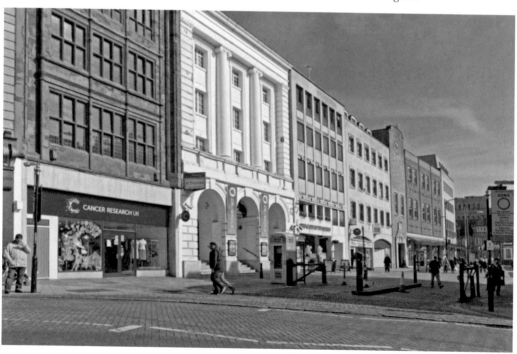

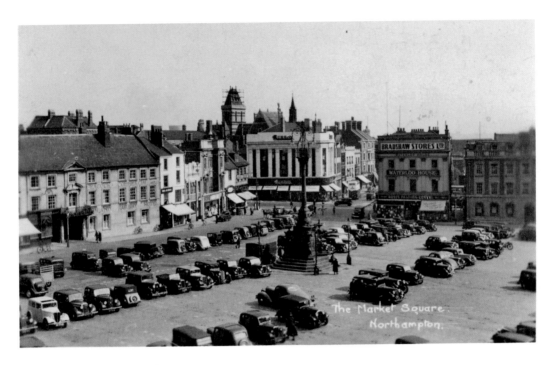

The Market Square in 1945

The Market Square is the second biggest in the country after Norwich. When not in use, it provided car parking after the war until this was banned in September 1975. The Peacock Hotel can be seen on the left, along with the huge Burton tailoring shop and the tower of the Guildhall in the background. The square does not attract as many stallholders nowadays, but regularly provides an arena for special events, with entertainment such as the morris dancing below.

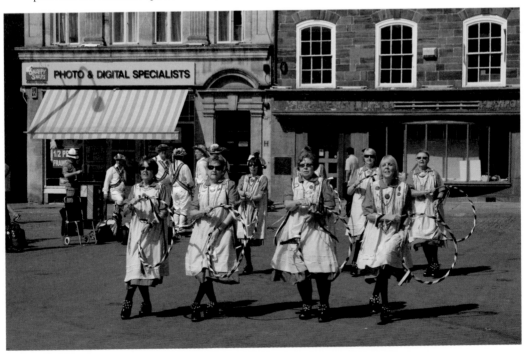

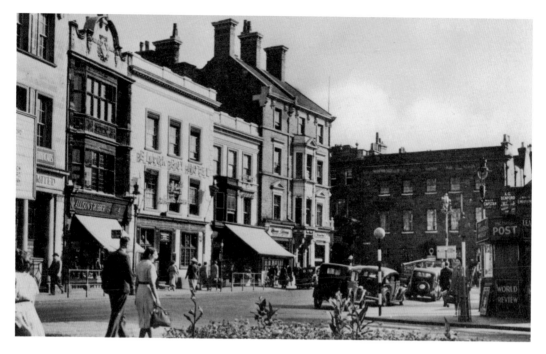

Wood Hill

Local woodmen sold their timber from the royal forests at a market here in earlier times, giving Wood Hill its name. Oliver Adams, the bakery, still has the shop on the far right corner, but the Black Boy, one of the town's oldest pubs, has now been replaced by a restaurant. On the right was the newspaper kiosk built from public subscription for Frank Eckford, a limbless veteran of the First World War. Originally it was in front of All Saints' church, but was located here until the road was widened.

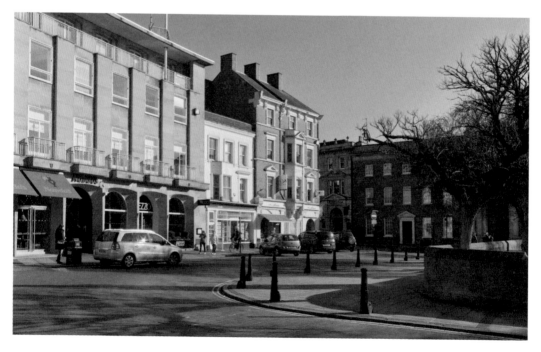

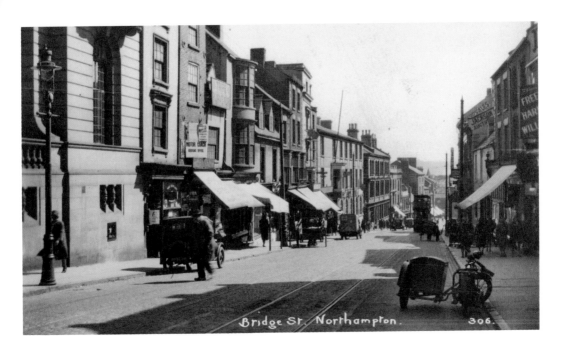

Bridge Street

Bridge Street, looking south from All Saints' church, was the main route connecting the town to the London Road. The steep gradient can clearly be seen, with a double-decker tram approaching the town centre. Two transport eras are overlapping as a motor coach booking office by the nearest van promotes trips to Yarmouth, Cromer and Norwich. The large board above it advertises a tripe purveyor. Opposite the tram was the former Angel Hotel, shown with scaffolding after a fire destroyed the nightclub there in 2012.

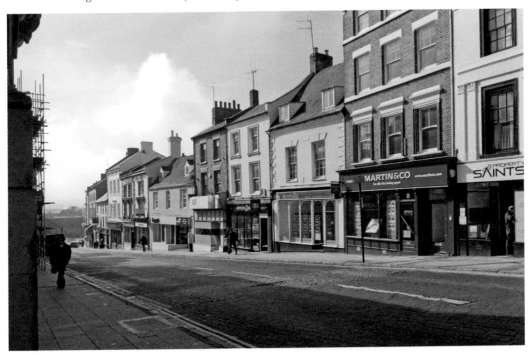

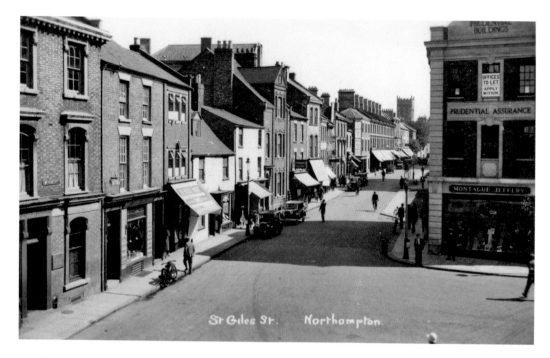

St Giles St. Northampton.

St Giles Street and the Guildhall Extension

St Giles church can be seen at the far end of the street that bears its name on the earlier photograph above. Montagu Jeffrey, specialising in high-quality menswear, still occupies the shop on the corner, but the modern extension to the 1892 Guildhall stands out on the opposite side. The design was chosen by public ballot from several suggestions. Two storeys of offices around a courtyard with cloisters to the east, in the red-brick structure, link it sympathetically with the original building.

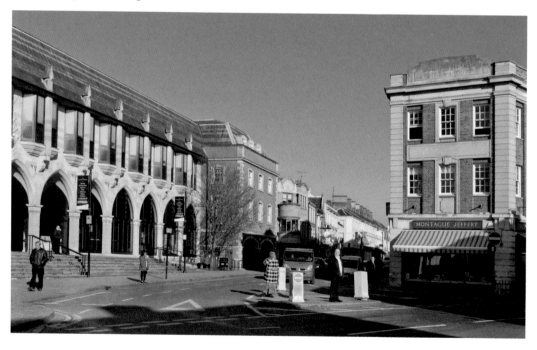

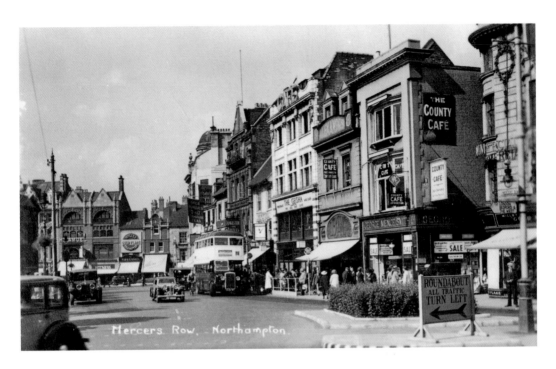

Mercer's Row

In this view from 1947, the old tramlines have gone and a double-decker bus is collecting passengers. A small roundabout controls traffic into Abington Street and Wood Hill. The County Café was accessed from a small jitty on the right leading to the Market Square. Further down is the Geisha Café and restaurant, and the wine merchants Lankester & Wells. In the background in the Drapery is Samuel the jeweller. Modern services now occupy the premises but taxis still wait to pick up passengers.

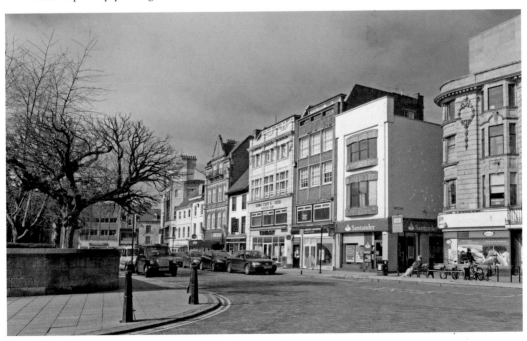

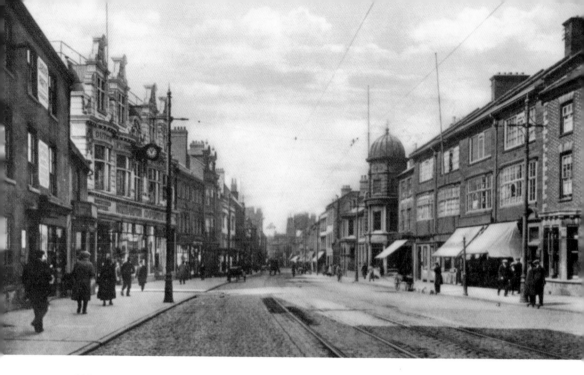

Abington Street

Now the main shopping street of Northampton, Abington Street appears quiet on this postcard of 1927, a few years before the tramlines were to disappear. The first premises on the left was the local Labour Party headquarters, and the Co-op is now gone and the premises used by other shops. The domed building opposite it was the offices of the Northampton Gas Light Company, purchased in 1908. The street is now pedestrianised, but is seen here in 2012 being used for parking for the Harley Davidson Motorbike Rally. This is an annual charity event to raise money for Cynthia Spencer Hospice.

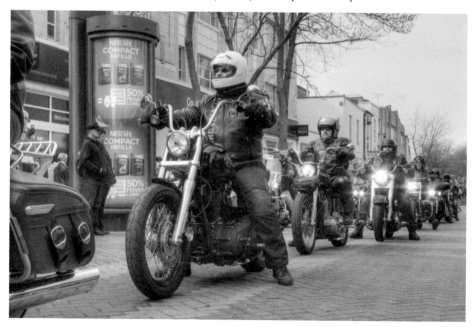

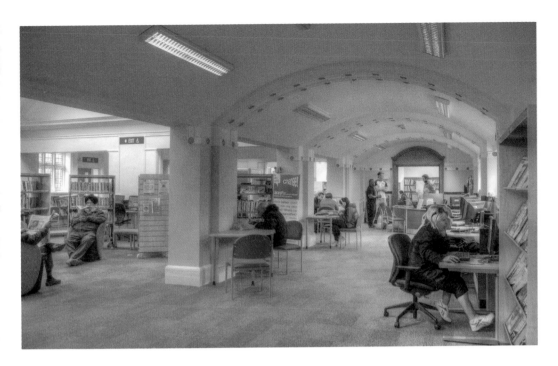

Northampton Central Library

Northampton Central Library began life in 1876 in the town hall with books donated by the Mechanics' Institute, before moving to Guildhall Road in 1883, running alongside the museum. The famous philanthropist Andrew Carnegie gave £15,000 for the relocated library, built of Weldon stone by Herbert Norman of Northampton and opened in 1910. Its site in Abington Street had been the depot for horses for the trams before the system became electric. The two pictures illustrate the changing emphasis of learning from books to multimedia resources.

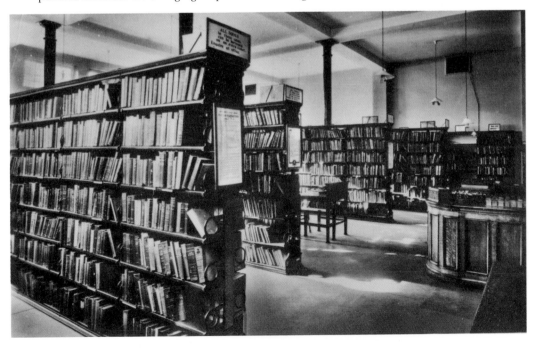

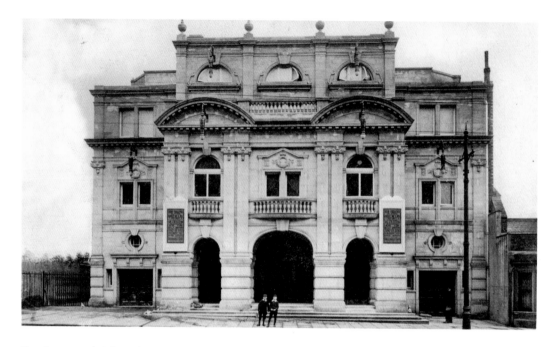

Northampton's Hippodrome

The New Theatre, known locally as the Hippodrome, was opened on 9 December 1912. It provided shows, concerts, musicals, ballet and opera, and was a popular venue until the post-war arrival of cinema and television. Many famous artistes appeared there. In its final years the entertainment became more risqué, culminating in the final show *Strip! Strip! Hooray!* in 1958. The Primark store now occupies the site, overlooked by the statue commemorating Northamptonian Francis Crick, co-discoverer of the structure of DNA.

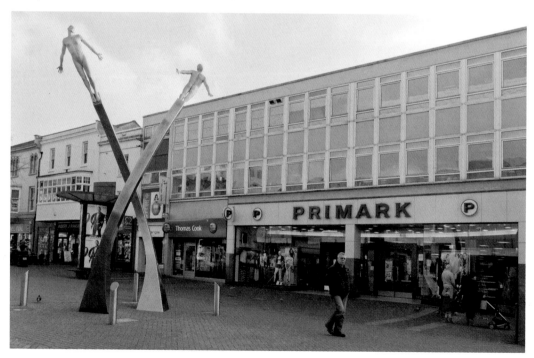

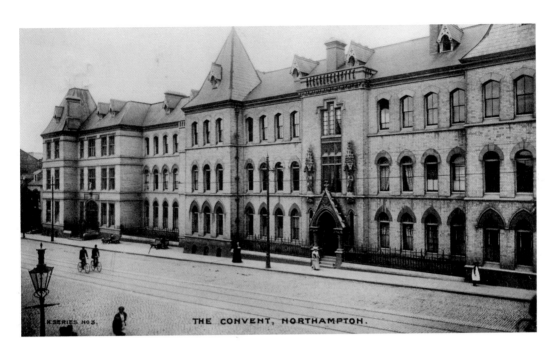

THE CONVENT, NORTHAMPTON.

The Convent of Notre Dame

For nearly a century, the imposing convent, built in 1879, stood at the top of Abington Street, and many Northampton women will remember their education at Notre Dame High School under the nuns' stern discipline. Closed in 1975, it was demolished four years later. A small cemetery of the Sisters, formerly in the grounds, survives in Albert Place. Today, Abington Street is a pedestrian zone, the red-brick and concrete façades over some shops are a far less attractive spectacle.

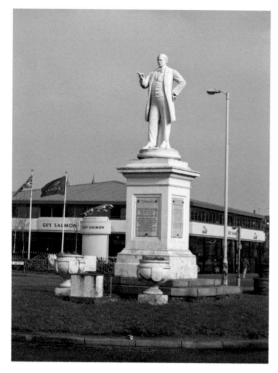

Remembering Charles Bradlaugh

Charles Bradlaugh was a leading radical and atheist of the nineteenth century, a champion of trade unionism, republicanism and women's suffrage, who founded the National Secular Society. Elected MP for Northampton in 1880, he asked for the right to affirm instead of taking the oath of allegiance, but was refused until a change was made to the Oath Act in 1888. Around 3,000 people attended his funeral. His imposing statue was in Abington Square in front of the People's Restaurant and Billiard Hall, a refreshment house run by the Blue Ribbon temperance organisation to benefit working men. This was demolished to make way for the Garden of Rest, and two steam rollers were used to relocate the immovable Bradlaugh a few yards away, where he now oversees a traffic island. His name survives in Bradlaugh Fields, a hall in Northampton University and, ironically for a teetotaller, the Charles Bradlaugh pub.

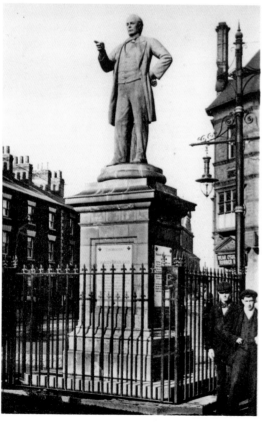

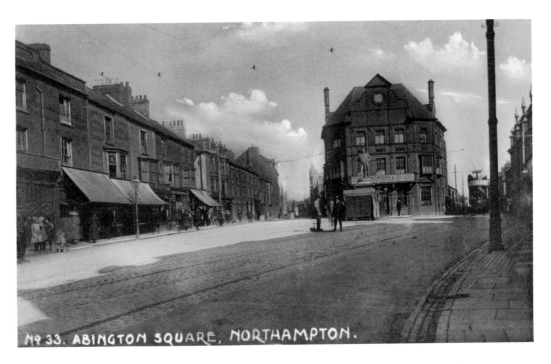

Nº 33. ABINGTON SQUARE, NORTHAMPTON.

Abington Square

In this photograph of 1923, Bradlaugh's statue can just be seen in front of the large, imposing building that stood at the junction of Wellingborough Road and Kettering Road. This was the People's Café from 1883 to 1908, then a leather mercer's and billiard hall. It was demolished in 1933 to make way for the Garden of Rest, built to remember the fallen of the First World War. The current view is far more open and the two roads part to create a one-way system.

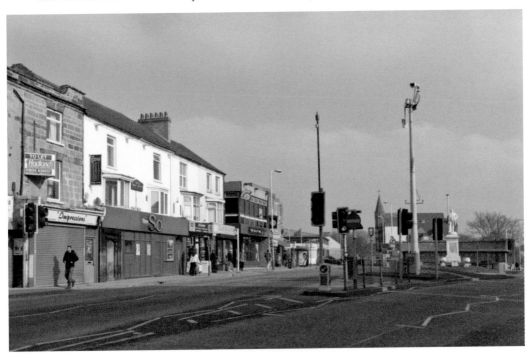

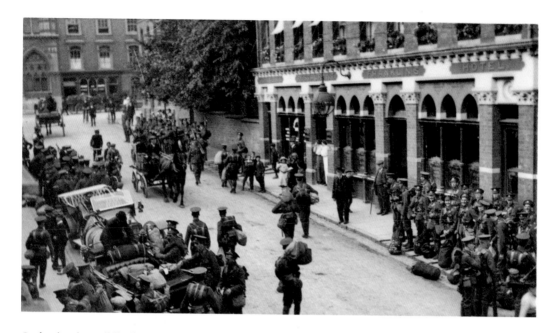

Gathering in Guildhall Road

During the First World War, soldiers of the Welsh Fusiliers and the Cheshire Regiment were billeted in the town, with a training camp on the Racecourse, and are seen here on manoeuvres in Guildhall Road. This postcard was posted to Holyhead in September 1914 by a soldier named Frank. The 2013 carnival parade passes the building on the right, currently a contemporary art centre that forms a cultural quarter with the adjacent Royal and Derngate theatres and the Central Museum opposite.

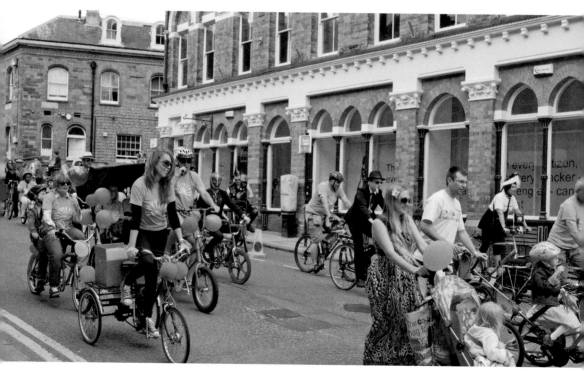

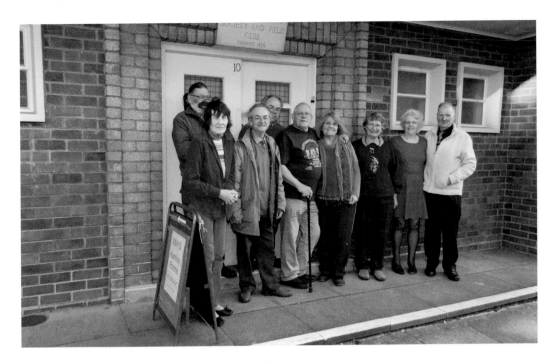

Photographers Abroad

The Northamptonshire Natural History Society was founded in 1876 and still boasts a thriving photographic section. Some of its current members are shown outside their base, the Humfrey Rooms in Castilian Street (*above*). The souvenir postcard below was addressed to Keighley Cobb, who produced photographs for postcards of Northampton hospital, asking him what material he had for a forthcoming lantern lecture. W. J. Basset-Lowke, the model-maker who also photographed for local postcards, is second left on the seated front row in the picture above.

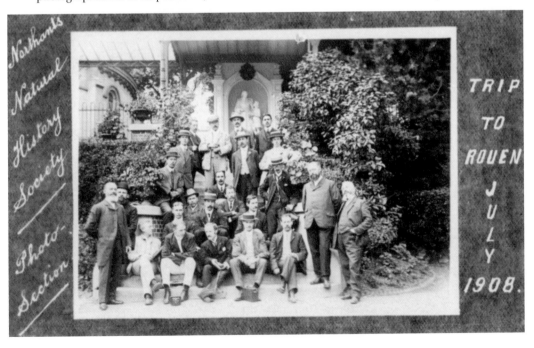

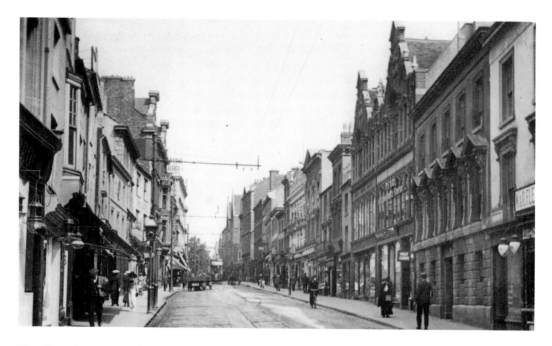

The Changing Status of Gold Street

Gold Street was once the main shopping street of Northampton before being superseded by Abington Street. In the 1960s, a range of clothing firms, furnishers, jewellers and department stores were based here, including Curry's, John Collier and Woolworths, alongside local big names Jeffery, Sons & Co. furnishers, Swann's tailors and outfitters, Bell's fireplaces, and the renowned bargain store of Frank Brierley. The current shops cater for a more downbeat market, with the snooker hall providing for leisure.

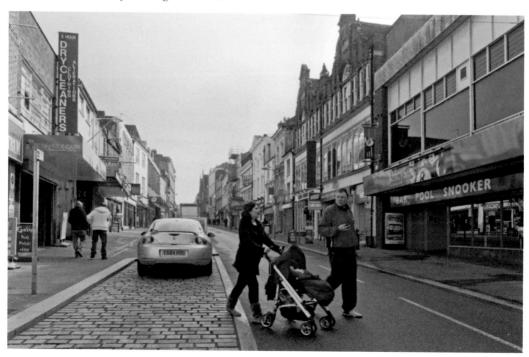

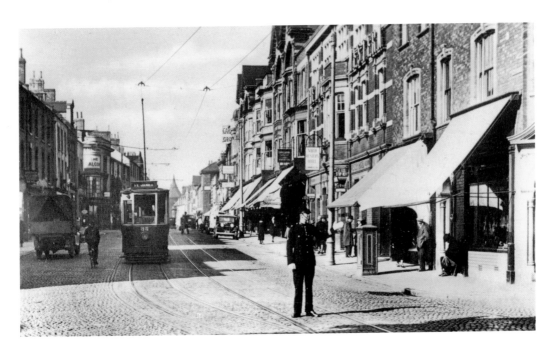

Marefair: *En Route* to the Station

On the north side of Marefair stood the North Western Hotel, which had been rebuilt in 1897 as the Rose & Punchbowl Hotel, before being renamed by the London & North Western Railway. It was replaced by the old Barclaycard building, visible beyond the modern cinema and hotel complex below. The tram was one of four bogie cars acquired in 1922. Marefair was once a busy thoroughfare between the railway station and town centre, but is now a quieter street off the inner ring road.

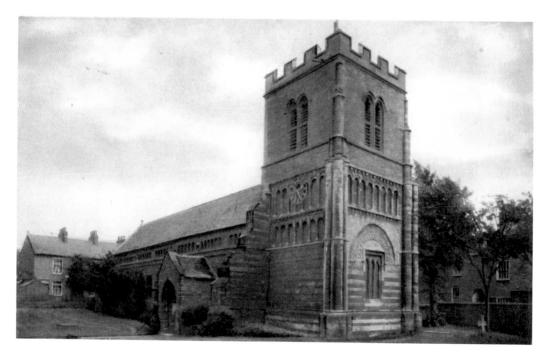

St Peter and the Birthplace of the Town

Close to the church of St Peter in Marefair, excavations have revealed evidence of Northampton's earliest Anglo-Saxon settlement. Replacing pre-Conquest places of worship, though much restored, it is considered the best Norman church in Northamptonshire. The fine arcading of the period is seen on the exterior view and the ornate carved capitals in the current interior. Also visible are the elaborate Victorian reredos. Now redundant, the church is a Grade I listed building cared for by the Churches Conservation Trust.

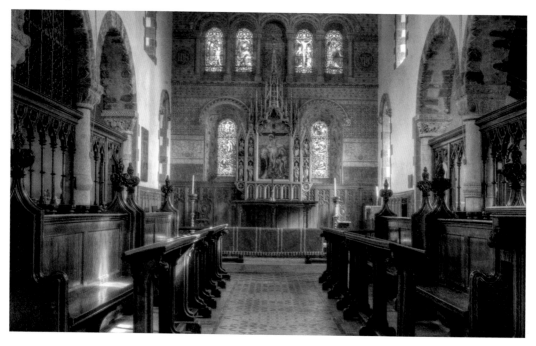

Black Lion Hill

The Grade II listed Old Black Lion is one of the oldest pubs in the town, probably dating back to medieval times. Next to it, the churchyard wall of St Peter's can be seen, and opposite is the site of the castle. The monolithic former Barclaycard building has replaced the array of shops on the north side. A bustling commercial quarter supporting the nearby station is shown on this postcard published by the newsagent on the right of the picture

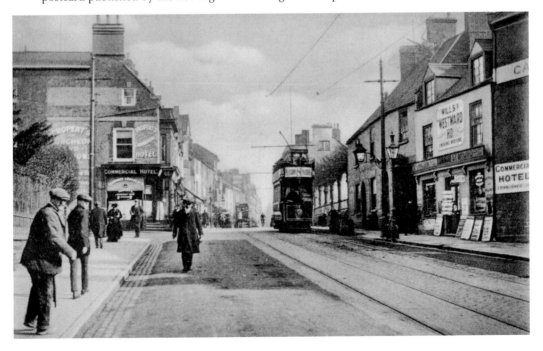

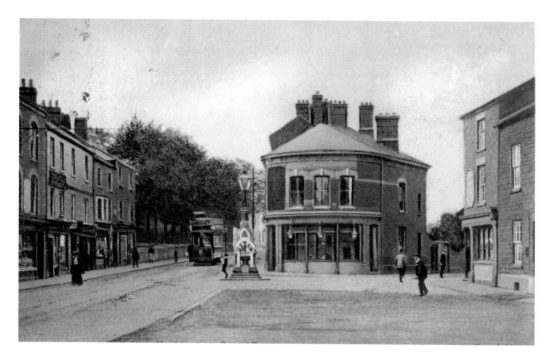

The Lost Monument of Regent Square

A tram passes Holy Sepulchre churchyard heading towards Kingsthorpe in the postcard above, sent in 1906 from Stanley Street, Semilong, which the writer describes as 'the suburbs'. The monument it is passing was a drinking fountain erected in 1860 by public subscription as a memorial to Revd Thomas Hutton, former chaplain of the County Gaol. It was demolished on 14 December 1953. The buildings next to it have been converted into a jazz bar.

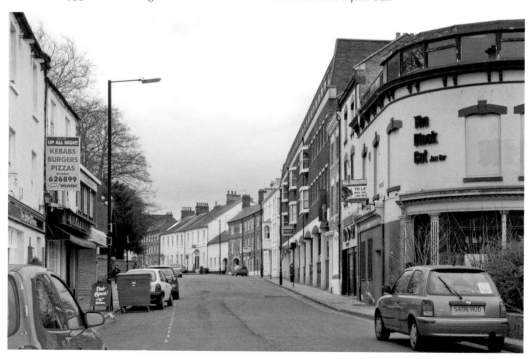

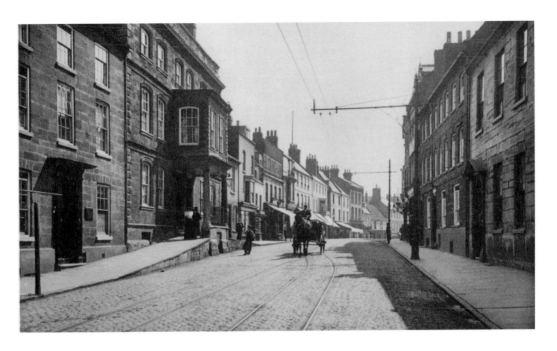

A Mayor's Mansion in Sheep Street

The house on the left of this view was owned by Dr Henry Locock, Mayor of Northampton in 1749, who added the sloping pavement so that he could step straight into his carriage. The house was occupied by the military during the First World War, and in 1927 the impressive room over the porch was removed, along with 'Locock's Hill'. A smaller bay window is there now. Sheep Street once held markets but no longer has shops like those shown above.

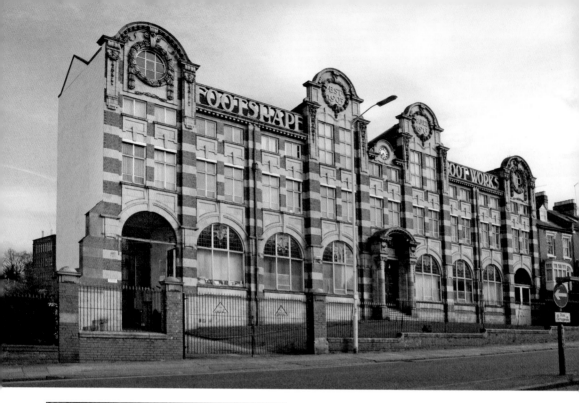

Shaping Up the Barratt Way

A tram passes in front of the Footshape Works, built in 1913 in Kingsthorpe Road, on this advertising card that offers boots by post, a system of supply pioneered by David and William Barratt ten years earlier. The name 'Footshape' came from the requirement of customers to provide a pencilled outline for the brothers to gauge the correct size of the boots ordered. This building along Barrack Road is now one of the few survivors of Northampton's once staple industry.

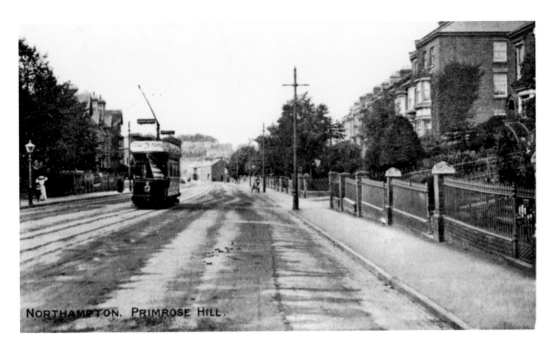

NORTHAMPTON. PRIMROSE HILL.

Uphill Traffic from Kingsthorpe

An electric tram heads towards the town centre after negotiating the incline from Kingsthorpe Hollow. This section of the system was electrified in August 1904. By 1932, necessary reconditioning of the tracks was deemed too expensive and motor buses started to be used. The last tram operated on 27 September 1933. The motor car, with accompanying road signs, now dominates the scene. The railings were removed for alternative use during wartime and boxes for today's waste recycling line the pavement.

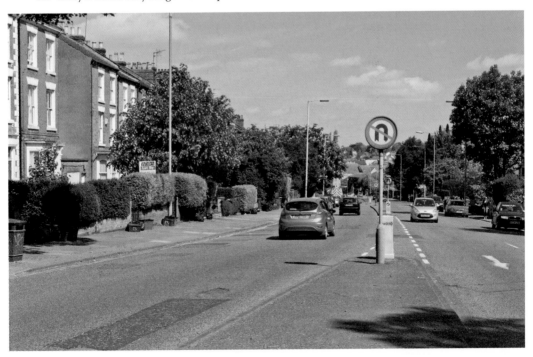

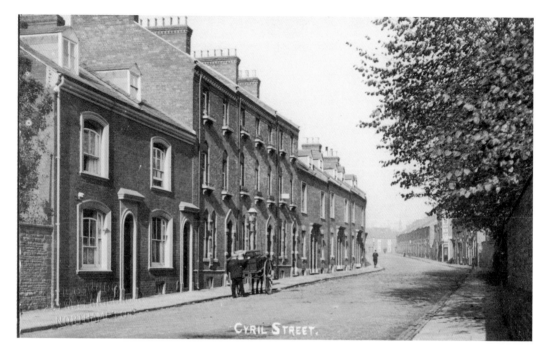

Cyril Street

Close scrutiny of this early postcard of Cyril Street shows a milk churn on the cart on the left, the postman on his round beyond it, an off-licence on the right, and two ladies dressed in aprons on the pavement further along. The street, off the Billing Road, is now one-way with parking restricted to permit holders only. The elaborate lintels of the doorways and the small balconies from the windows still survive on the houses on the left.

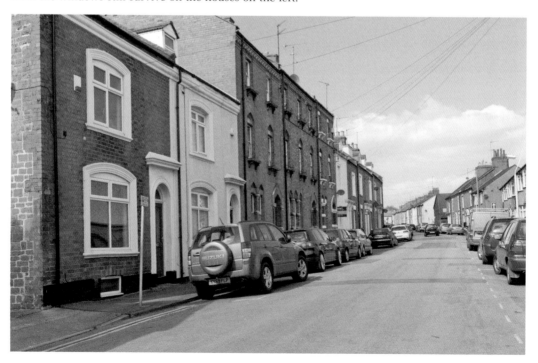

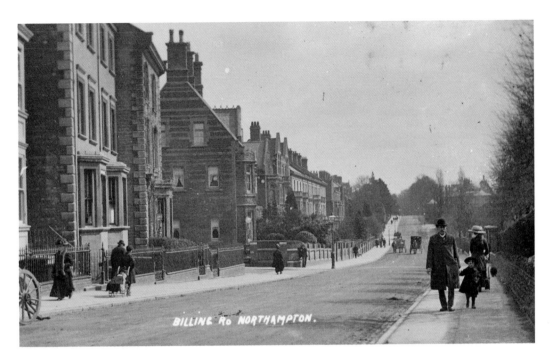

Parading Along the Billing Road

The postcard above was sent by a soldier in September 1914 and he writes of parading along this stretch of road every morning. This was not on one of the tram routes and many walkers can be seen, along with a couple of horse-drawn cabs in the distance. The large houses on the edge of the town are now occupied by businesses and enterprises, and the preferred modes of transport to Cliftonville, the General Hospital and the town centre are bus and car.

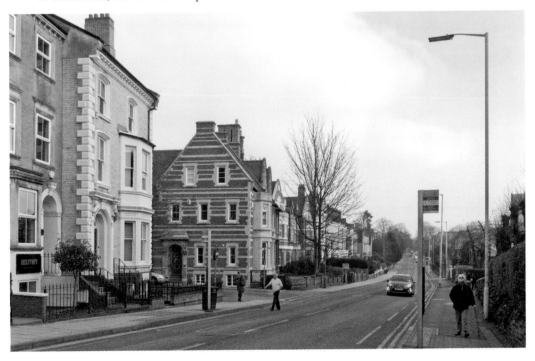

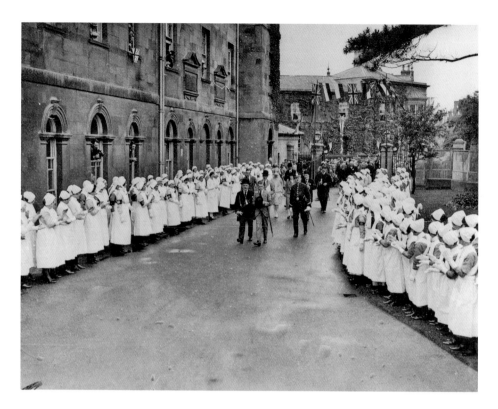

A Royal Visitor to the Hospital

The seventh day of the seventh month of 1927 was regarded as an auspicious date for the visit of the Prince of Wales, the future Edward VIII. Here, nurses line the route as he approaches the entrance of the General Hospital. Carrying his umbrella on what turned out to be a wet day, he is accompanied by the Mayor James Peach, whose daughter he visited in a private ward where she was a patient. Today, the staff car park occupies this area.

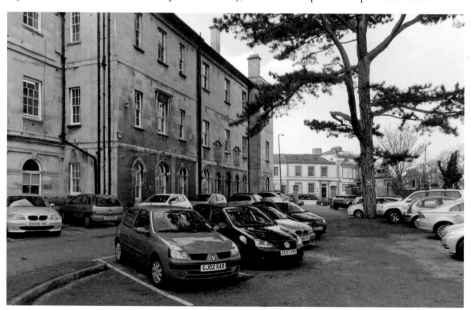

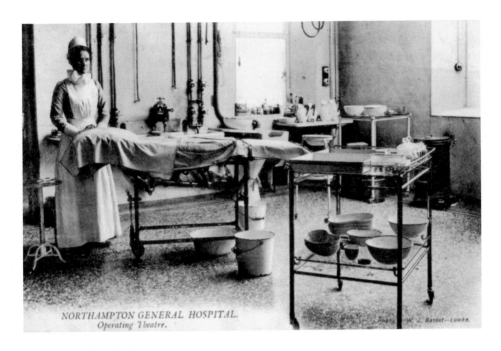

NORTHAMPTON GENERAL HOSPITAL.
Operating Theatre.

A Theatre of Distinction

Northampton General Hospital was built in 1793 and funded by subscriptions. This photograph of the operating theatre, rather basic in comparison with modern standards, is one of a number taken by W. J. Basset-Lowke. It had electric lighting and the first anaesthetic was given here in 1847, only three months after its very first use in Boston, Massachusetts. The photograph below shows one of the administrative offices of the NHS Trust hospital, which today has fourteen operating areas.

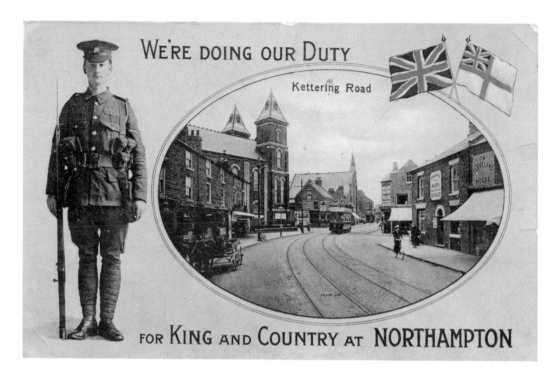

WE'RE DOING OUR DUTY

Kettering Road

FOR KING AND COUNTRY AT NORTHAMPTON

Serving on the Kettering Road

During the First World War, when the above postcard was sent, the Welsh Fusiliers were stationed in the town and could be seen on manoeuvres along Kettering Road. The Methodist church commands the view, with a family butcher's on the corner of Grove Road beyond. The line of buildings on the right has now gone and there is a grassy area in front of Exeter Place. A stream of cars has replaced the tram. Jones The Furnishers have occupied the red-brick building in the background for over forty years.

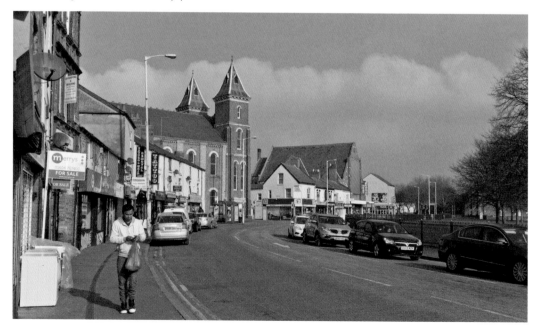

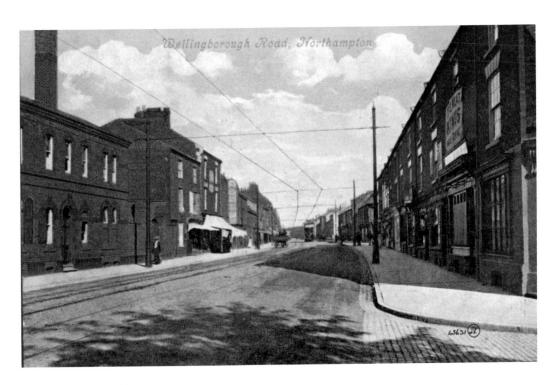

The Old Workhouse

The prominent building on this view of Wellingborough Road, posted in 1906, is the workhouse. It was built in 1836, at a cost of around £7,000, to accommodate 300 inmates. The designer was the famous Victorian architect George Gilbert Scott, whose career began with workhouses. It was taken over by the Borough Council in 1930 and continued as St Edmund's Hospital until 1998. It is currently undergoing restoration (*seen below*). Further along is the Spread Eagle public house, dating from 1850.

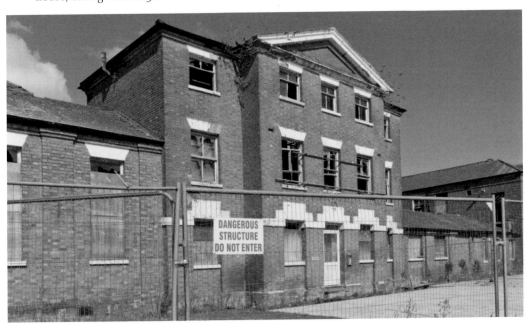

39

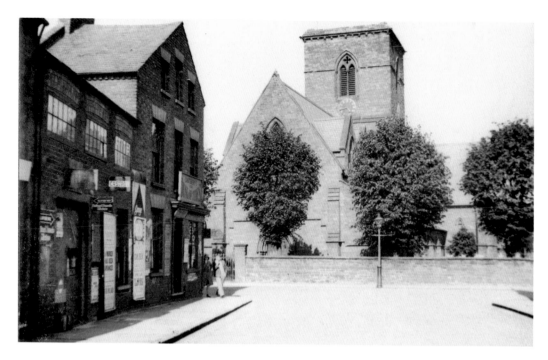

St Edmund's Bells Ring Out in New Zealand

The original St Edmund's church stood by the town's east gate. The building shown above was built around 1850 by W. J. Hugal of Cheltenham and its nave was remodelled by Matthew Holding. It seated 900 and the tower was originally intended to carry a spire. The church was closed in 1978 and demolished in 1980 as the building was unsafe. The churchyard remains enclosed alongside Wellingborough Road. Eight bells were rehoused in St Paul's Cathedral in Wellington, New Zealand.

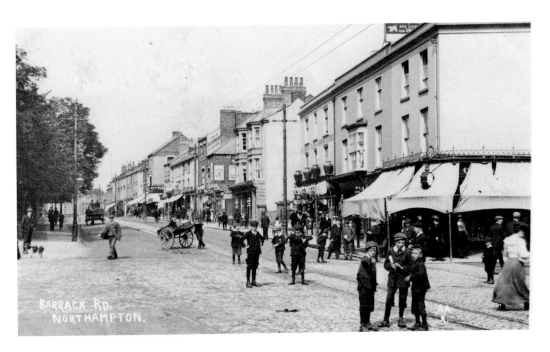

The Changing Face of Barrack Road

Barrack Road in 1907 has Paynes the furnishers advertising repairs of all kinds, reflecting a different society from today's throwaway one. Burman, a long-established dairyman in Northampton, also has premises here. Schoolboys loiter on the tramline and awnings shield shopfronts from the sun in this busy scene. A coal merchant's cart can be glimpsed on the left of what is now largely a through road for traffic. The view below, taken diagonally opposite, is now occupied by a modern casino.

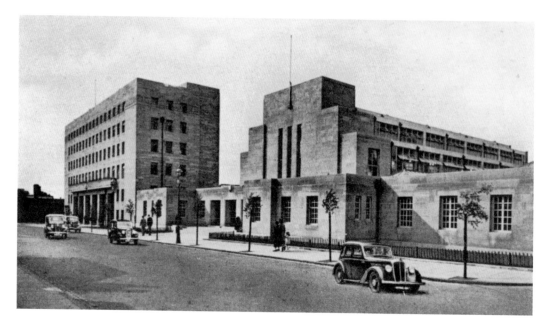

The Fire Station and Swimming Pool

Northampton's fire station opened in 1934 and the Mounts Swimming Pool opened two years later. The exterior view remains unchanged, though the pool is now part of a modern fitness and leisure centre. The driving force behind its construction was the model-maker W. J. Bassett-Lowke, and its unique interior makes it one of the few working Art Deco pools in the country. It cost £52,000 – more expensive designs having been rejected – and the town prison was demolished to make way for it.

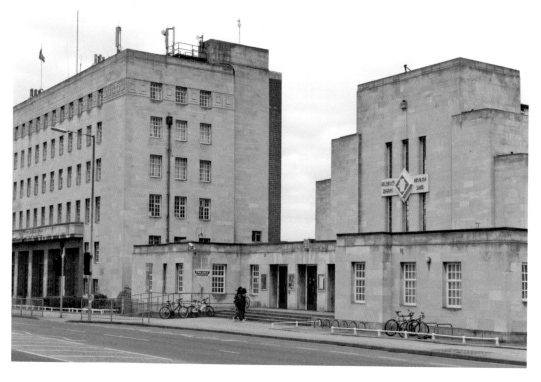

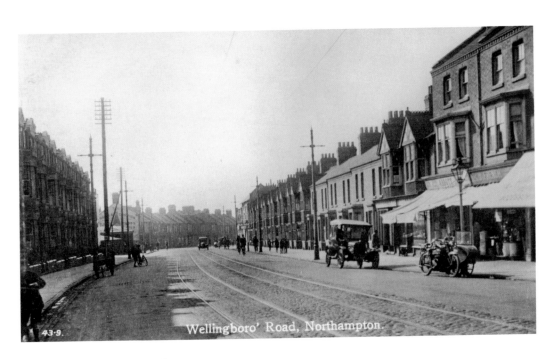

Wellingboro' Road, Northampton.

Wellingborough Road

The Wellingborough Road widens as it leaves town towards Abington. The tramlines are clearly visible and were a popular form of transport before this section was closed in 1929. Motor cars are just coming onto the scene. The large townhouses have been taken over by small businesses, branches of the large banks and the Co-op supermarket, which stands on the corner of Barry Road below. The Crown & Cushion (*middle left*) still stands at the corner of Collins Street.

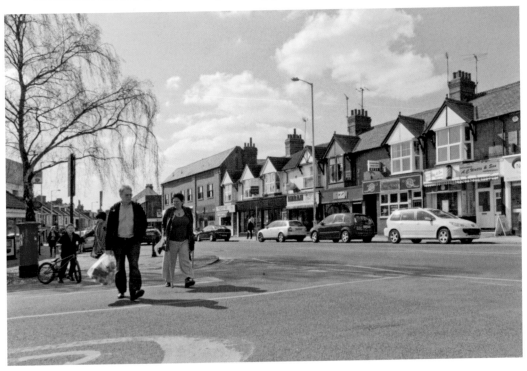

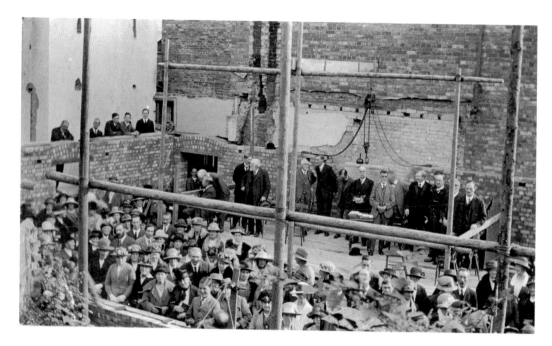

The Building of Christchurch

At the junction of Wellingborough Road and Christchurch Road, Christchurch was another building designed by Matthew Holding. He was also responsible for the Guildhall, Abington Park Hotel and the local churches of St Matthew's, Holy Trinity and St Mary's in Far Cotton. The laying of the foundation stone in 1904 is shown above, and the church, built of material from a Kingsthorpe quarry at a cost of £6,100, was consecrated in May 1906. It was intended to have a pinnacled tower, but this was never built.

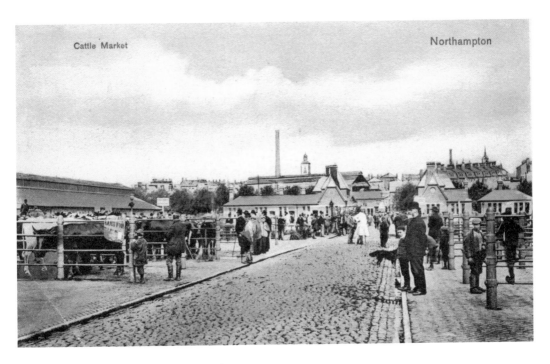

Cattle Market Northampton

From Cattle Market to Supermarket

In 1873, the purpose-built cattle market was opened on the south side of Victoria Promenade. Previously, livestock had been penned and sold on the Market Square and surrounding streets, echoed in names such as Sheep Street, Horse Market and Marefair. The site now bustles with cars and a steady stream of shoppers into Morrisons supermarket. The cattle market was moved to Brackmills, until it suffered huge financial losses after the foot-and-mouth outbreak and closed in 2002.

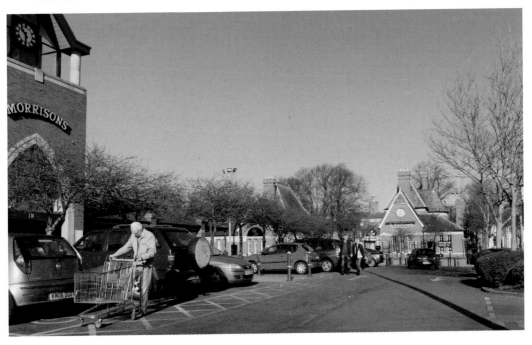

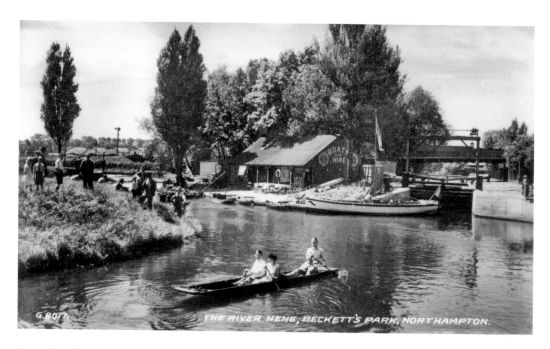

THE RIVER NENE, BECKETT'S PARK, NORTHAMPTON.

Boats for Hire on the River Nene

Northampton lock is on the right of the view above, and next to it is the old boathouse, built before the First World War. Several small craft are moored in front of it, ready for hire. A group of boys are fishing on the bank opposite at what was clearly a popular spot for recreation. In the new Northampton Waterside Enterprise, this will form part of Becket's Park Marina, the boats of which are shown here.

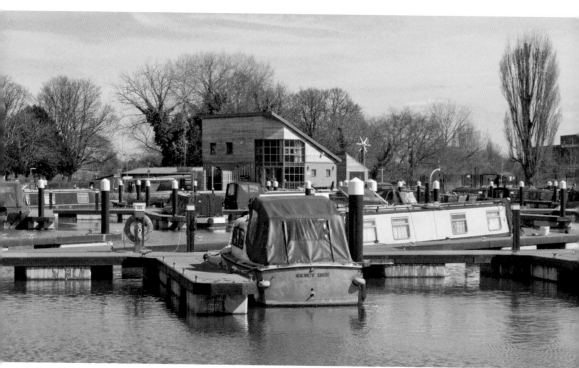

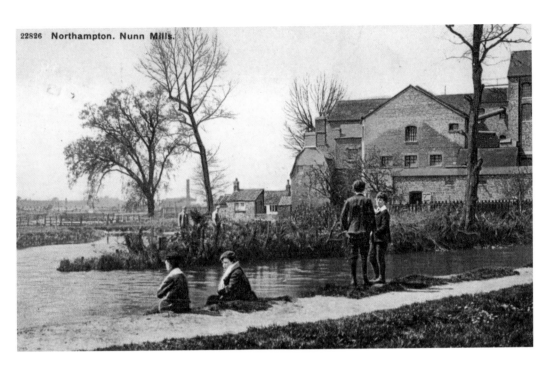

From Nuns to Cosmetics

Nunn Mills was downstream from Northampton lock on the outskirts of the town. Its name came from the nuns of Delapre Abbey who once owned it. Three mills stood under one roof, hence the plural. Joseph Westley of Blisworth leased the mills in the 1860s and used the Nene to transport wheat and coal for steam power. The site closed in 1964 and Avon Cosmetics redeveloped it. It will form part of the Northampton Waterside Enterprise Zone.

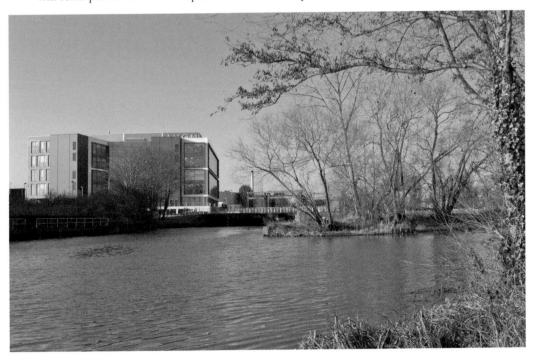

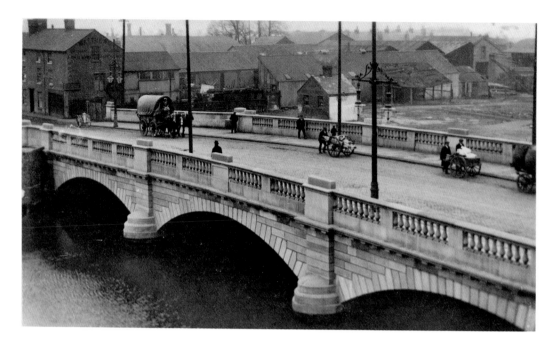

Crossing the South Bridge

The photograph above shows South Bridge after it had been widened from 30 to 50 feet in 1913. The contractor, Mr W. Higgins, was paid £6,495 for the construction in Derbyshire stone. Wagons and hand-drawn carts are shown crossing towards Far Cotton, with Matthews the blacksmith's in the top-left corner. The current view is taken from the opposite direction – the structure remains unchanged, but modern lighting standards and the recent extension to Carlsberg are dominating the view.

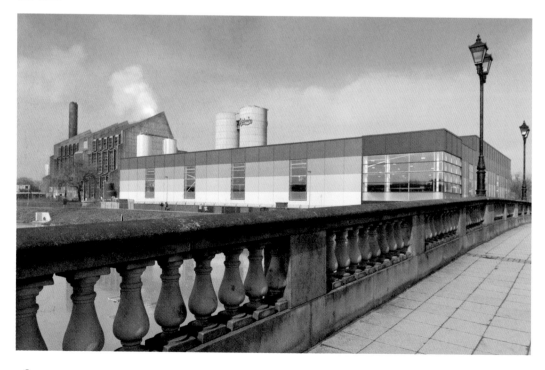

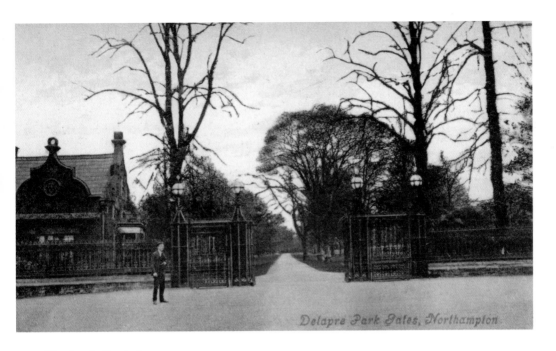

Delapre Park Gates, Northampton

The Battle for Delapre

Delapre Abbey, situated in meadows of the River Nene to the south of Northampton, was founded by Earl Simon de Senlis II in 1145. In 1460, the second Battle of Northampton was fought nearby. King Henry VI was captured and held prisoner for the night in the abbey. The future of the abbey remains uncertain at present. The Friends of Delapre Abbey have restored features of the old gardens, and Lottery funding is being sought to ensure the future of the building.

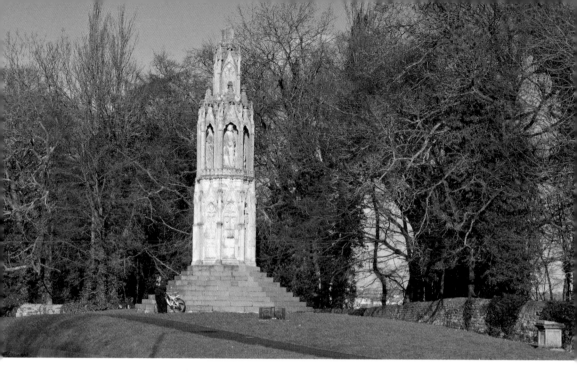

Fit for a Queen

A cyclist pauses to use his mobile phone by Queen Eleanor Cross on the London Road. Modern Northampton is just in view behind the wall through a gap in the trees. This is now a few hundred yards from the outer ring road, but the earlier photograph hints at a more rural scene. The hunt shown was probably the Pytchley. When Eleanor of Castile, wife of Edward I, died in 1290, her body was transported to Westminster Abbey, and a cross was erected at the twelve places where the cortège rested, one being here at Delapre Abbey. Only three crosses now survive, of which two are in Northamptonshire.

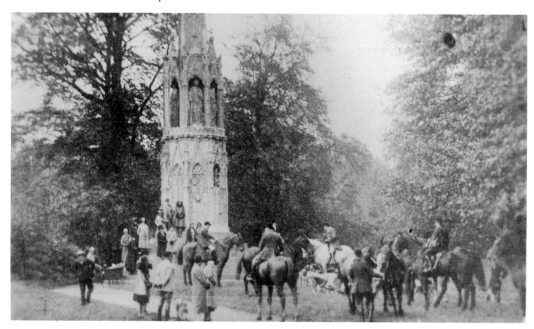

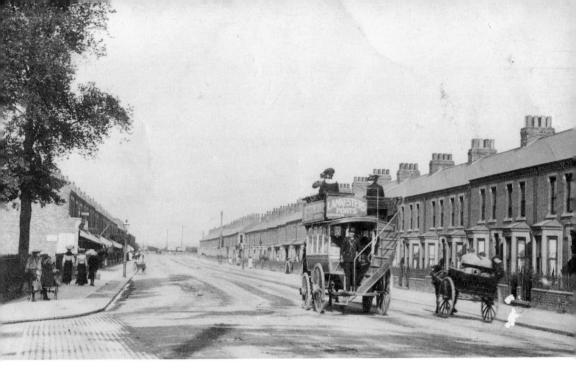

St Leonard's Road, Far Cotton

St Leonard's Road ran through Far Cotton, leading to Towcester, and was named after a hospital and leper house that once stood nearby. The postcard above bears a Far Cotton postmark of 1906. A horse-drawn tram continued on this route until 1914, because of the difficulty of negotiating the gradient of Bridge Street, and the railway and river crossings. This one advertises Lankesters, wine merchants, in Mercer's Row. Fast-food shops, television aerials and motor cars reflect modern living in the street today.

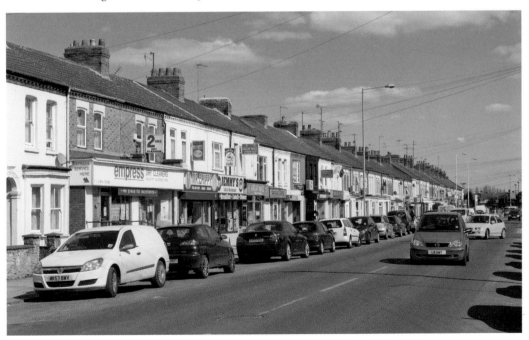

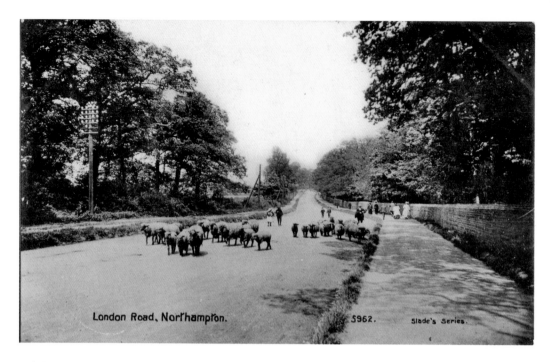

London Road, Northampton. 5962. Slade's Series.

Driving Along the London Road

A flock of sheep is being driven from the cattle market towards Hardingstone and Wootton in this early view posted in 1914, a familiar sight until 1955 when increased motor traffic rendered it unsafe. The wall of the grounds of Delapre Abbey on the right was removed in the 1980s. The only form of movement visible is foot traffic. An urban landscape now replaces this country scene, as a stream of traffic heads towards the town past modern housing and the Carlsberg brewery.

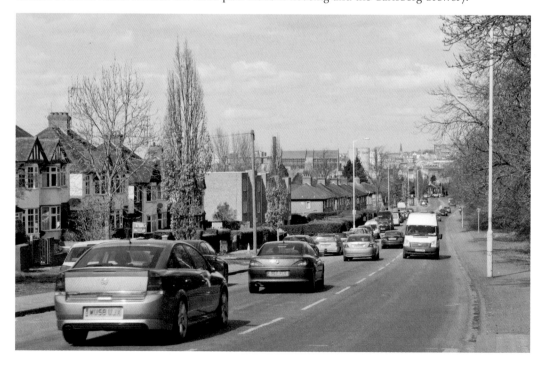

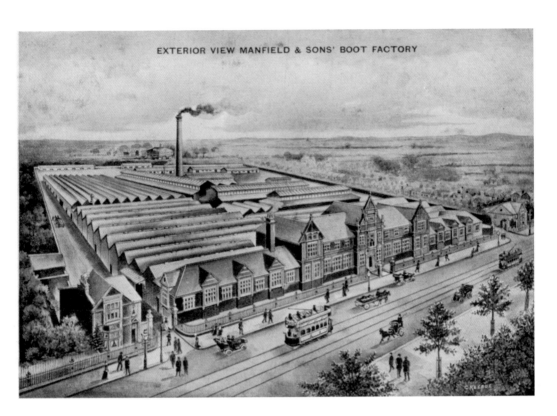

A New Style of Factory

The traditional Northampton shoe factory had three and a half storeys, with heavy machinery housed in the basement and the clickers working on the top floor. The revolutionary Manfield factory on the Wellingborough Road replaced Monks Park Spinney and opened in 1892. Surrounded by open fields, it incorporated all of the processes on one level. Above, four types of transport pass by: horse and dray, hansom cab, electric tram and motor cars. The building is now an Indian restaurant.

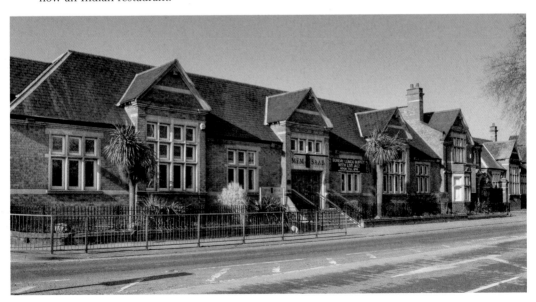

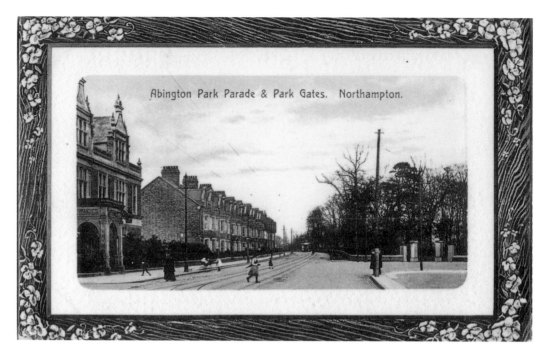

Abington Park Parade & Park Gates. Northampton.

By the Park Gates

On this postcard of 1910, an electric tram makes its way down the Wellingborough Road towards the main gate of Abington Park. By 1928, the track on this route was considered beyond economic repair and buses were used alongside the trams, before superseding them in 1929. The right-hand pillar of the gate bears the date of the park's opening, – 21 June 1897. Opposite it, the Abington Park Hotel still stands, built in a French Renaissance style by Matthew Holding in 1898.

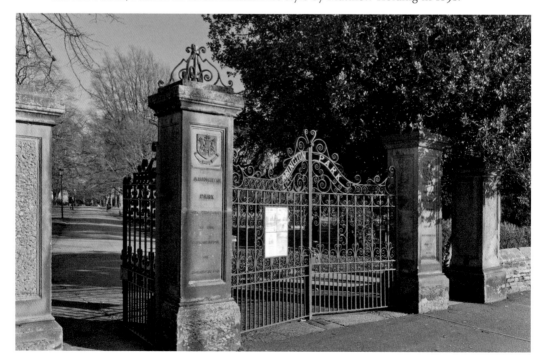

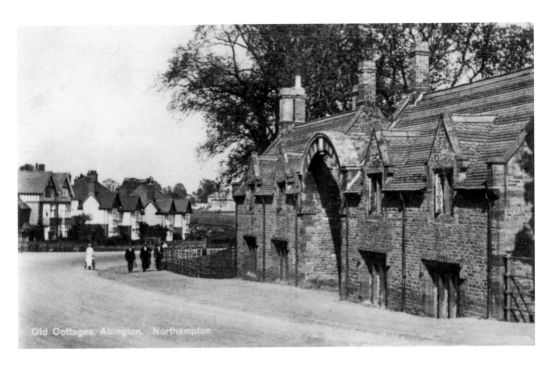

Old Cottages, Abington. Northampton

The Archway Cottages

The Archway Cottages were built in the seventeenth century opposite Plum Lane, now Park Avenue North. In the above photograph of 1926, the ground-floor windows can be seen, but a succession of road schemes has brought them half below ground level. They housed shepherds and wagoners from the estate, and the stables held chain horses to help wagons up the hill towards town. Adjacent to a busy roundabout, after being empty and derelict, they have been restored for private accommodation.

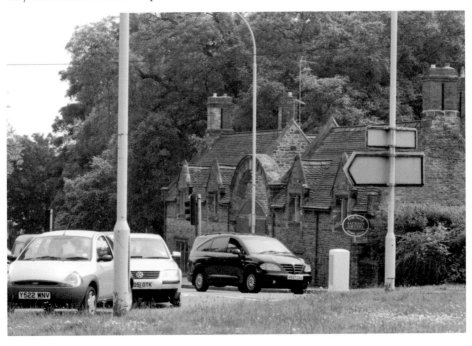

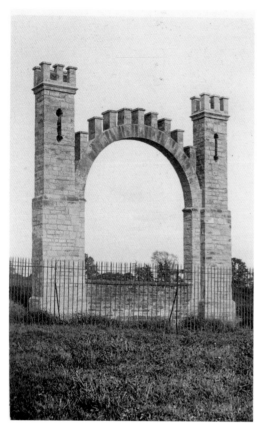

The Old Entrance Gate to the Town
In 1669, William Thursby, who was MP for Northampton in 1698 and 1701, had bought the manor of Abington for £13,750, and one of his descendants constructed this castellated archway in the early nineteenth century, described as the old entrance gate to the town or the Hunting Gate. Today, only the two piers remain and there is a new road, Abington Park Crescent, lined with residential housing replacing the old view across open country.

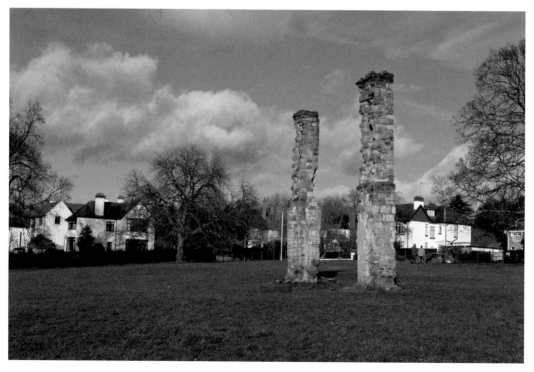

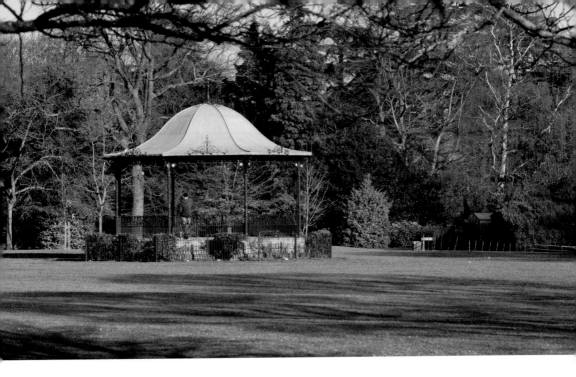

Bands in the Park

To mark Queen Victoria's Diamond Jubilee, the bandstand in Abington Park was constructed between March 1898 and May 1900, when it held its first concert. An iron fence surrounded an enclosure around the bandstand, with chairs, for which a fee of 6d was charged. Concerts were popular, particularly in the years leading up to the First World War and entertainment was provided by some of the best bands in the country. The bandstand has been given a facelift in recent years.

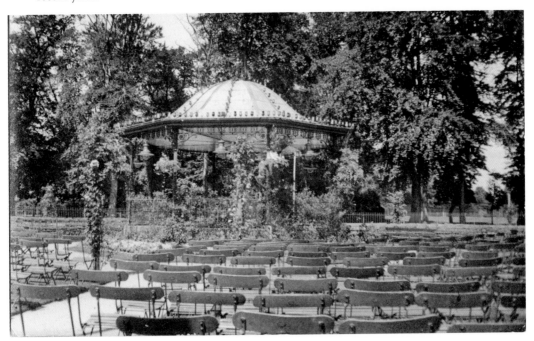

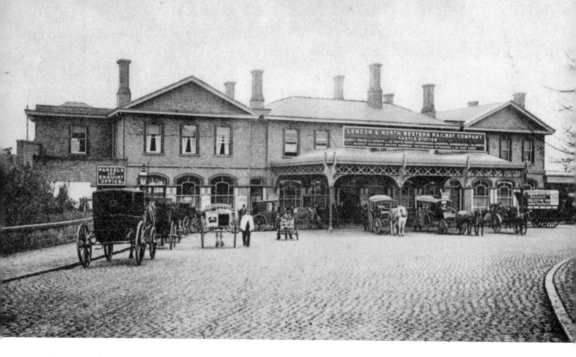

From Castle to Railway Station

Built on the site of the medieval fortress, Castle station was connected to the main line near Roade in 1882. This postcard published by Boots the chemist shows it as part of the London & North Western Company, and a group of carriages and carriers can be seen in a thriving scene. It was run subsequently by London, Midland & Scottish before nationalisation in 1949. The site is scheduled for massive modernisation in the near future, providing better links with London and Birmingham and faster journey times.

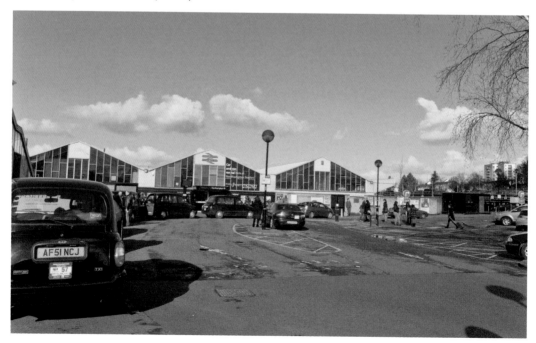

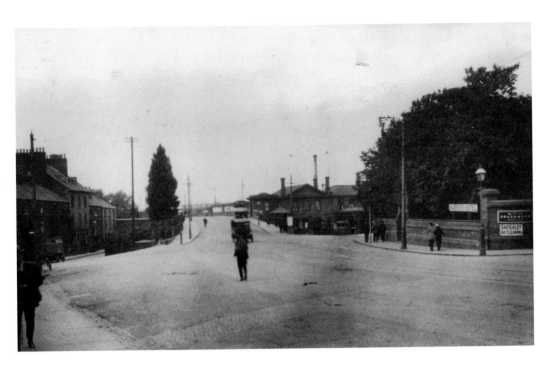

West Bridge

Before the town was enlarged in 1900, West Bridge formed the western boundary. The London & North-Western Railway (LNWR) met most of the cost when it was rebuilt to a width of 30 feet and opened to traffic in 1857. With the arrival of the trams, however, the bridge became a bottleneck, and in 1903 its width was increased to 50 feet. The building of St Peter's Way and the inner ring road, with the demolition of Western Terrace, provides a different view today.

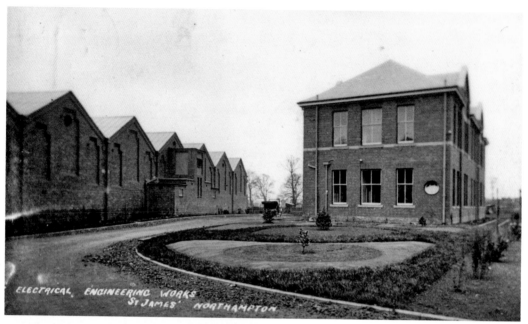

ELECTRICAL ENGINEERING WORKS
ST JAMES' NORTHAMPTON

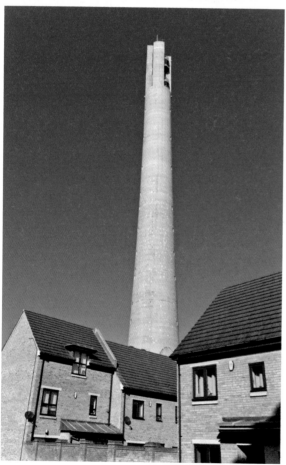

Giving the Town a Lift

In November 1982, a lift testing tower built by the Express Lift Company off Weedon Road, was opened by the Queen. Dubbed by broadcaster Terry Wogan the 'Northampton Lighthouse', it has become a familiar landmark to local travellers. It is the only such tower in the UK and, after it fell out of use when Express Lifts was taken over by Otis in January 1997, it was granted Grade II listed building status. In 1999, Wilcon Homes acquired the site for development. The building is now the privately owned National Lift Tower, used by companies for development, research and testing. The postcard above, posted in 1911, portrays the engineering works on the site prior to Express Lifts. The location was part of the former Augustinian Abbey of St James. Excavations were carried out prior to development in 1999–2001 and provided much valuable information on Northampton's past.

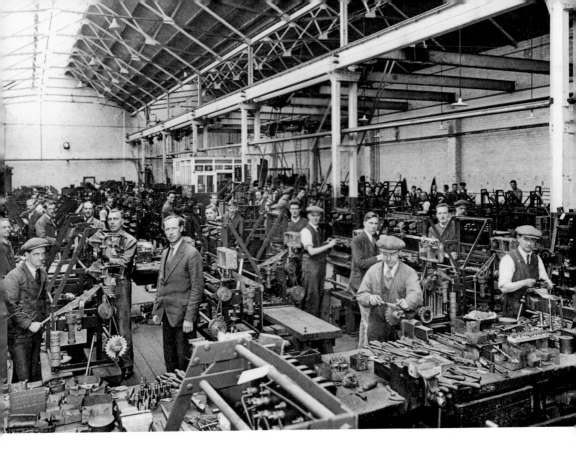

Workers Inside the Abbey Works

Smith, Major and Stevens (Smiths Majors to local employees) came to Northampton and built the Abbey Works on Abbey Park, originally planned as an extension to Franklins Gardens. The fine engineering factory was completed in 1909 to employ 280 people, and was a bold venture in an area where boot- and shoemaking was the well-established, predominant trade. A block of modern flats occupies the site of the old works today.

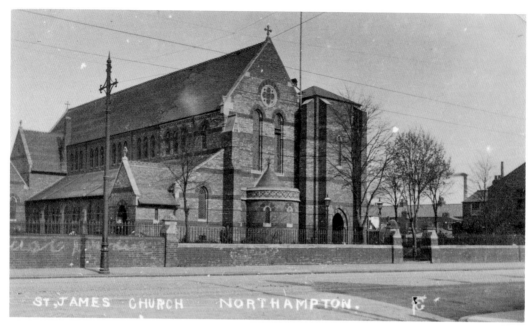

ST. JAMES CHURCH NORTHAMPTON.

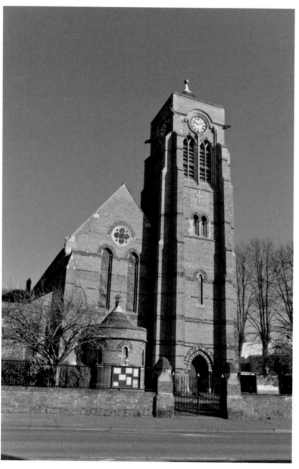

A Tower to the Fallen
The red-brick St James church
was built in 1868 to provide for
the spiritual needs of occupants
of the extensive new housing, to
the west of Northampton from the
industrial expansion of Boot and
Shoe. The high clock tower, which
now dominates the area, was
added in 1920. It was built as a
monument to those who lost their
lives in the First World War from
the contributions of parishioners,
including the Congregational and
Methodist churches.

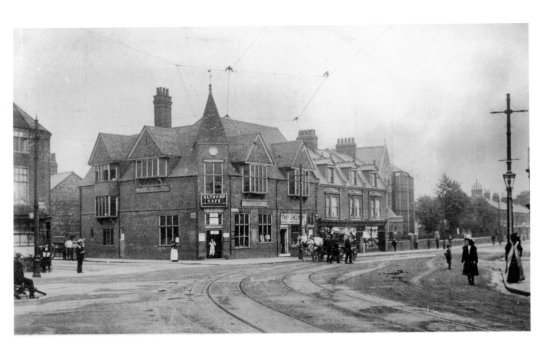

The Café on the Square

The Althorp Café, at the junction of the Harlestone and Weedon Roads in St James, became so popular that the area was known as Café Square. It is now the NatWest Bank. Trams travelled from here to the terminus a quarter of a mile along Weedon Road at the Red House, later the Red Rover and now the Rover pub. The busier road of today does not allow pedestrians to mingle and the church has its large tower.

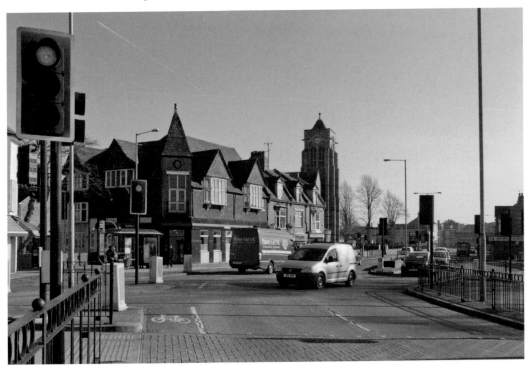

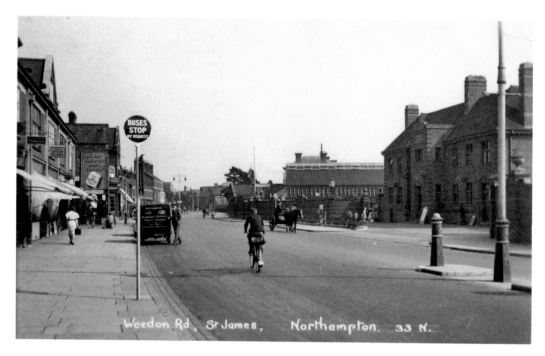

Weedon Road

Weedon Road looking towards St James, on this card posted in 1942, shows the Franklins Gardens Hotel on the right, and projecting beyond it the *Salon de Danse*, reputed to be the best dance hall in the Midlands at the time. The old Shellmex garage is on the left, just beyond the parked van. The shop signs advertising various brands of cigarettes and tobacco contrast sharply to those of the present fast-food outlets, as do the details on the two vans.

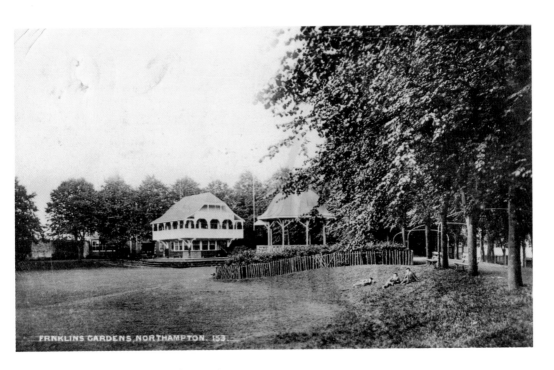

FRANKLINS GARDENS, NORTHAMPTON. 153

Sport and Recreation at the Gardens

Originally, Melbourne Gardens were named after Lord Melbourne who owned an estate at Duston. John Campbell Franklin bought them in 1886 and sold them privately two years later for £17,000. The main lawn with bandstand and refreshment pavilion is rather empty on this postcard of 1911, but a racecourse, cycle track, cricket ground, swimming pool and menagerie made it a very popular venue. Today, the name Franklins Gardens survives in the impressive stadium of Northampton Saints Rugby Union Club.

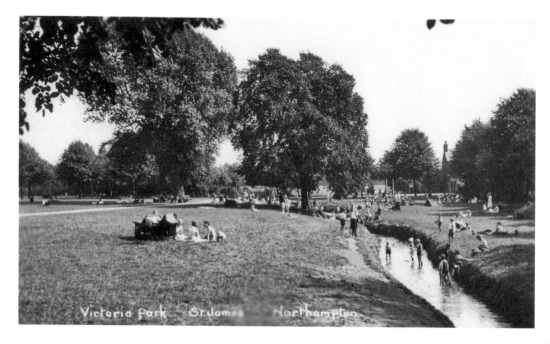

Hordes in Victoria Park

Victoria Park was given to the town by Earl Spencer to mark Queen Victoria's Diamond Jubilee in 1897. The card above was posted in 1935. The sender was on holiday for health reasons and comments on the 'terrible hot weather', which fits this scene. Sadly, large numbers of children enjoying such freedom and simple pleasure is a thing of the past, and the park is largely deserted now, though each spring, daffodils adorn the scene in the Field of Hope for Marie Curie Cancer Care.

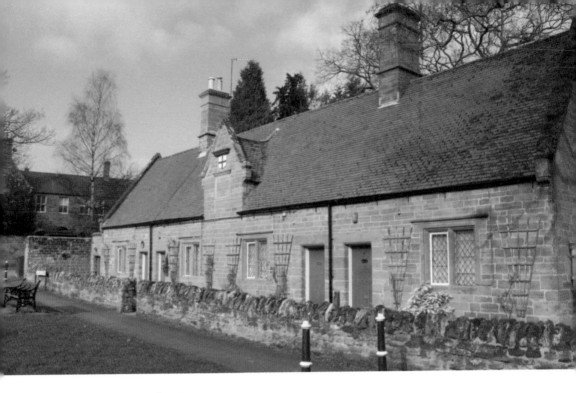

Dallington Conservation Area

A fine collection of buildings standing around Dallington village green comprises a picturesque conservation area. Above are the Raynsford Almshouses, founded in 1673 by Richard Raynsford, a lawyer who was Chief Justice to the King's Bench under Charles II. They still retain their original use for elderly people. They stand around the corner to the left from the old postcard view, looking down Raynsford Road towards the green, behind which stands the Old Forge, accessed by bridge across the brook.

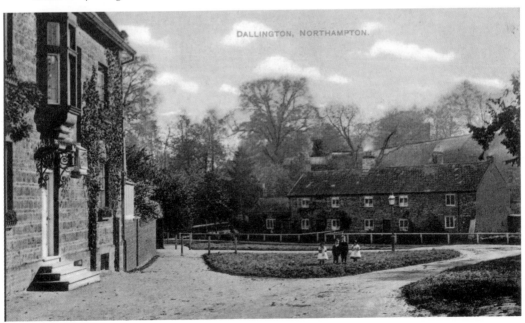

DALLINGTON, NORTHAMPTON.

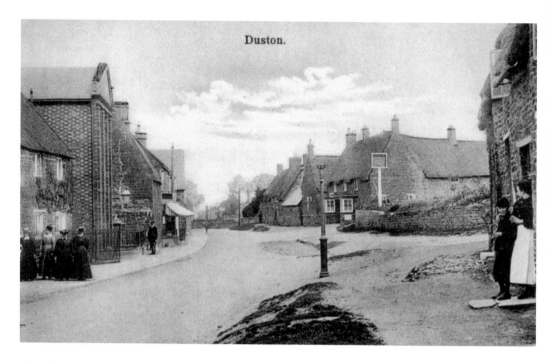

Duston.

The Old Village in Duston

The village scene on a postcard in 1923 shows The Squirrels public house, named after those displayed on the coat of arms of the Samuel family of nearby Upton Hall. In the background on the right is Bank Cottage, built in the sixteenth century from the remains of St James Abbey and originally a single farm dwelling. On the opposite side are the old Baptist chapel and the village stores. The Squirrels still remains, but in the modern scene the street has lost its original rustic charm.

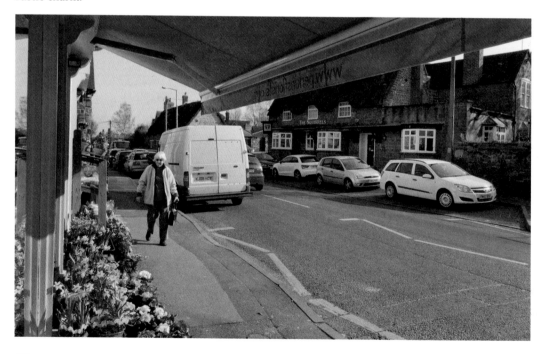

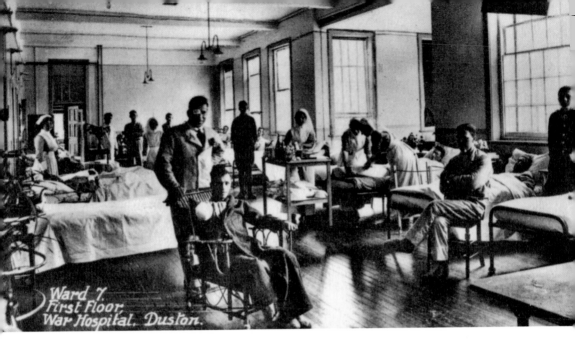

Ward 7,
First Floor,
War Hospital. Duston.

Wounded Soldiers at Berrywood

Built in 1876 as the County Lunatic Asylum, St Crispin's Hospital, originally known as Berrywood, served mental patients until its closure in 1995. It served as a war hospital from October 1915, until the last of the wounded soldiers left in March 1919 and the mentally ill patients returned from temporary residence in other asylums. The buildings are being restored to provide accommodation for the elderly and a new mental health facility. The tower of the asylum can still be seen next to part of this conversion.

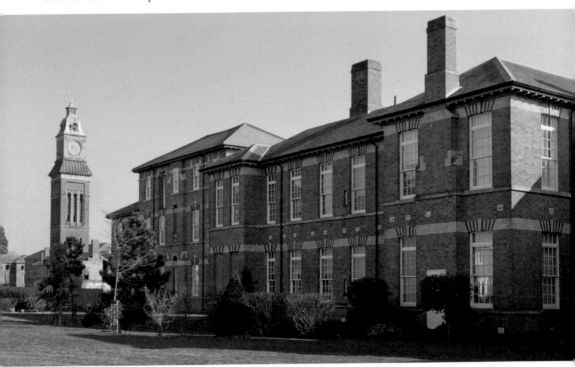

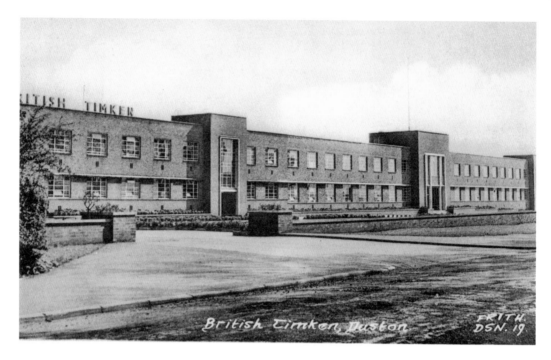

The British Timken Works in Duston

British Timken opened a factory in Duston in 1941, once owned by the American Roller Bearings Company. It used to be one of the town's largest employers. The main building was demolished in 2005 after the factory closed down. The 67-acre site was turned over to a development of 480 houses with public open space and community facilities, including the medical centre below. The existing sports hall was retained and a whole new range of amenities created.

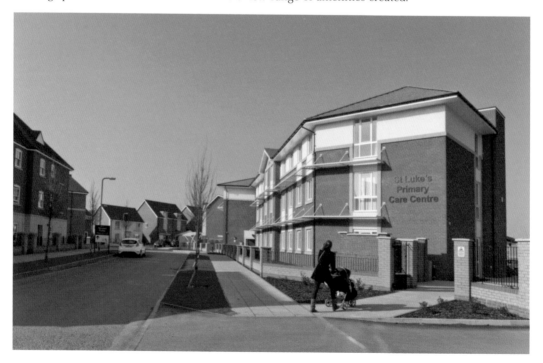

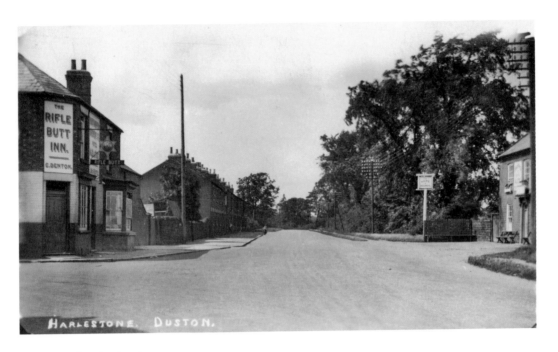

HARLESTONE. DUSTON.

Two for the Road

Two public houses face each other on the Harlestone Road in this postcard from around 1930 (the sender refers to a visit to the 'talkies'). G. Denton had been landlord of the Rifle Butt for some years for the Northampton Brewery Company. It originally had large gardens, which are now used for car parks. Today it is the Hart of Duston, the road sign to Quarry Road on its side wall echoing an important industry here. Opposite was the Hare and Hounds, owned by the Phipps Brewery which is now closed.

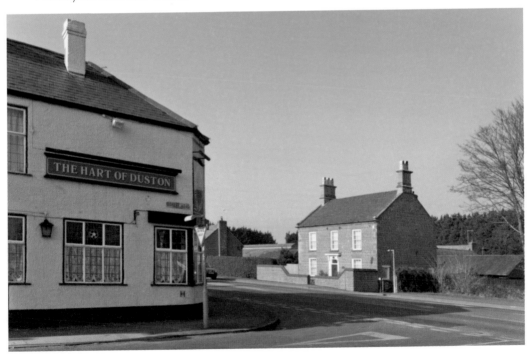

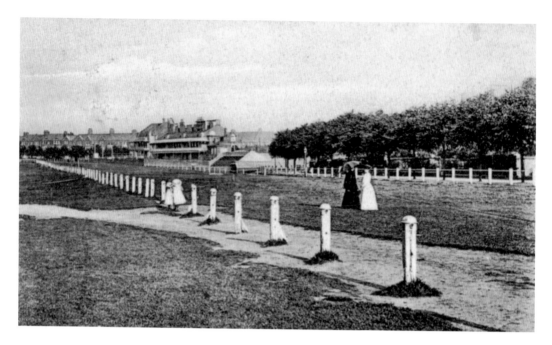

Days at Northampton Races

Horseracing began on the site unofficially in 1632, before regular meetings were held twice a year in the nineteenth century. Unfortunately, the racecourse was crossed by several public rights of way and, after a series of serious accidents, was pronounced unfit for racing and closed in 1904. Above is the old grandstand and part of the anticlockwise circuit. A community group now has a lease to turn the building's ground floor into a café, vegetarian restaurant and community centre.

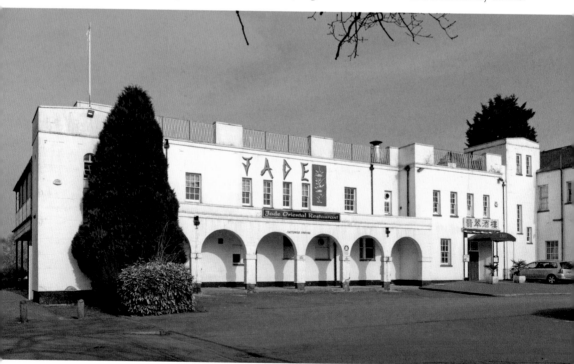

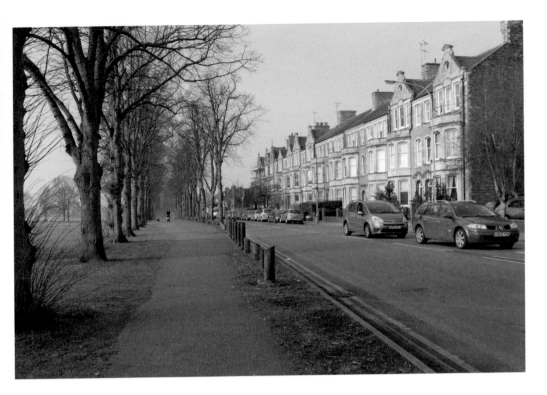

St George's Avenue and the Racecourse

St George's Avenue today is a busy thoroughfare linking Kingsley Road and Kingsthorpe Road, which converge in Kingsthorpe at the Cock Hotel. The large, three-storey, bay-fronted stone dwellings, which can be seen clearly today, were hidden by trees in the postcard of 1948 (*below*) when it was a quieter scene. The wide expanse of the racecourse is visible on the left. The annual Northampton Balloon Festival was held here until it was moved to Billing Aquadrome in 2009.

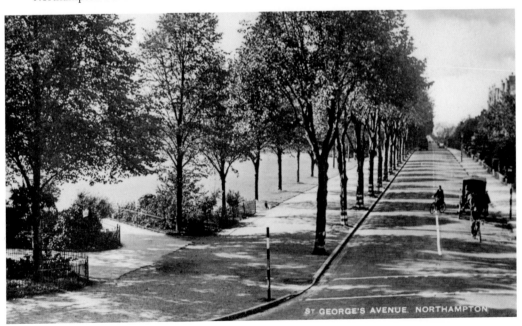

ST GEORGE'S AVENUE, NORTHAMPTON

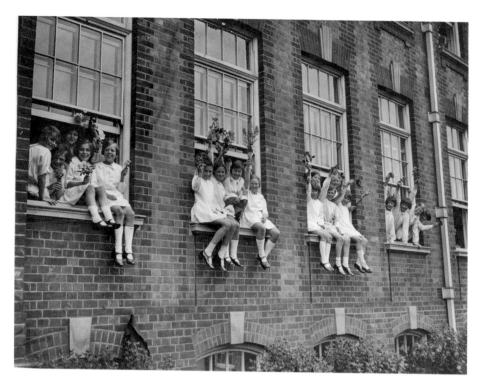

Three Cheers for the Prince of Wales

During his visit to the town in 1927, the Prince of Wales, the future King Edward VIII, visited Northampton School for Girls, where girls from Northampton High School and the convent of Notre Dame High School also assembled dressed in white. He was presented with purses of money for the National Playing Fields Association and gratefully suggested a week's extension to the summer vacation, hence the joyous farewells made with little concern for health and safety. The school building is now part of the University of Northampton.

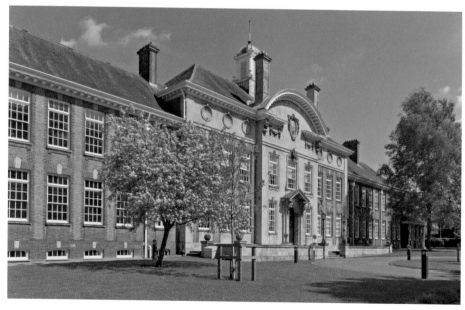

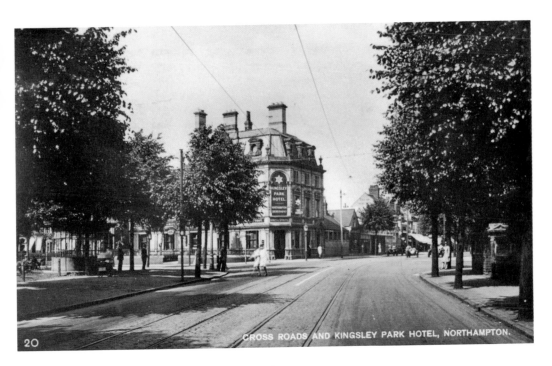

CROSS ROADS AND KINGSLEY PARK HOTEL, NORTHAMPTON.

20

White Elephants at the Kingsley Crossroads

In 1883, a syndicate of sportsmen built the Kingsley Park Hotel to accommodate the hordes of people who visited the racecourse on race days. After the course closed in 1904, the remote location made the building a 'white elephant'. In the 1950s, the brewery company applied to assign the popular name to it and this remains today. The tram shelter on the corner of the old racecourse opposite it, built in 1924, became a similar 'white elephant' a few years later when that era of transport ended.

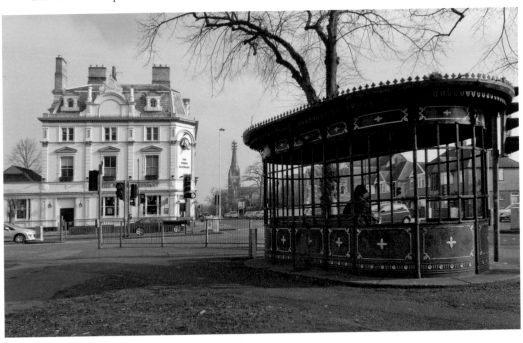

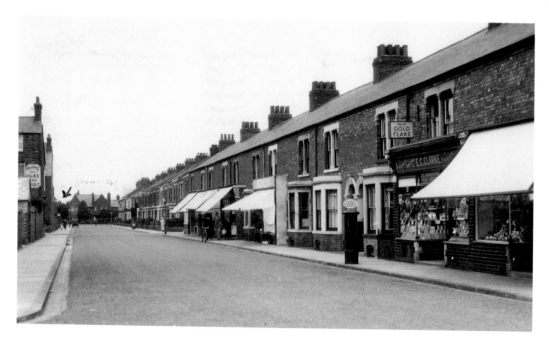

In a Side Street in Kingsley

Collingwood Road was one of the streets built in Kingsley as the town spread towards Abington in the early twentieth century. A small arrow on the postcard points to No. 47, from where it was sent in 1935, probably from the post office on the right, now closed and housing an ironing service. The old coal cellars have been boarded up, satellite dishes punctuate the skyline and cars occupy the previously empty street. An off-licence stands opposite the now closed public house.

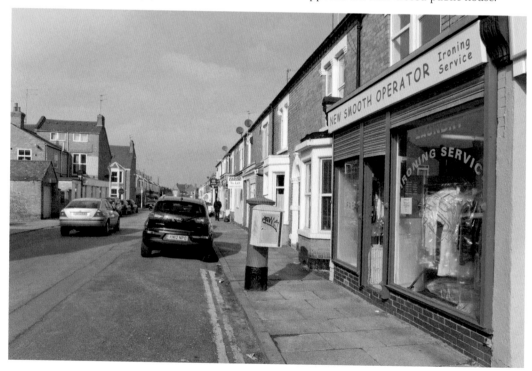

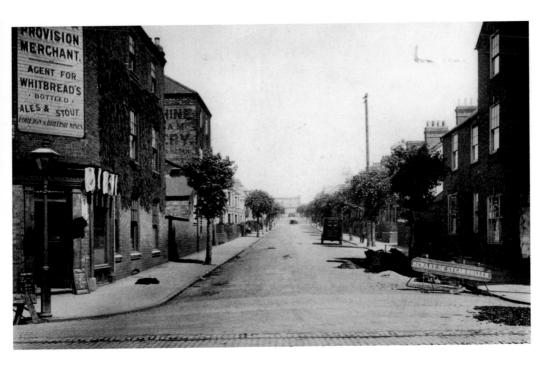

Adams Avenue

The roadworks on the right of this view of Adams Avenue, off the Wellingborough Road, around 1920, carry a sign 'Beware of the Steam Roller'. A bread van is just beyond it. The corner off-licence has boards outside with 'today's prices' and 'special buys'. The street has fewer trees now, and the corner premises is owned by a property management company. Parked cars, one-way and 20 mph signs, along with the young lady checking her mobile phone, complete the modern scene.

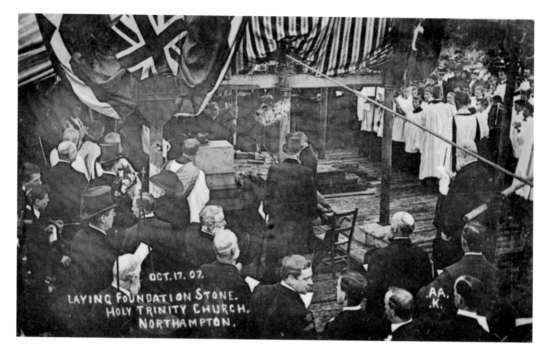

OCT. 17. 07.
LAYING FOUNDATION STONE.
HOLY TRINITY CHURCH.
NORTHAMPTON.
.AA.
.K.

Old Stones Used in a New Church

Holy Trinity parish came into being in the nineteenth century to meet the growing needs of the community of Queen's Park. The owner of a ruined medieval building attached to St David's Hospital provided the stone that was built into windows of the choir vestry. Lady Knightley of Fawsley laid the foundation stone of Holy Trinity church, designed by local architect Matthew Holding and completed in 1909. The large, imposing structure towers over Balmoral Road and is a Grade II listed building.

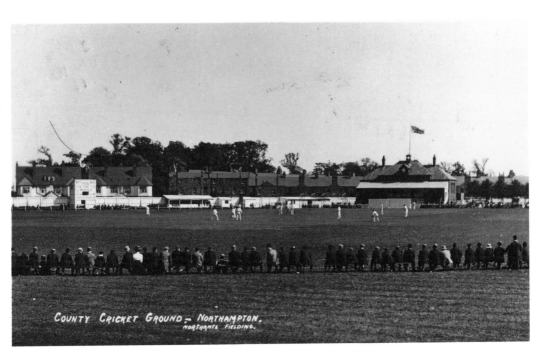

COUNTY CRICKET GROUND – NORTHAMPTON.
NORTHANTS FIELDING.

Anyone for Cricket?

Spectator comfort was at a premium in this view of the county cricket ground in a postcard of 1911. The venue was shared by Northampton Town Football Club until Sixfields Stadium was opened in 1994. The photograph is taken from the football ground, which had no grandstand on that side. The Wantage Road part has changed little, but a rebuilt pavilion, modern cricket school and huge floodlights have raised the ground's status. Here, it is shown two weeks before the start of the 2013 season.

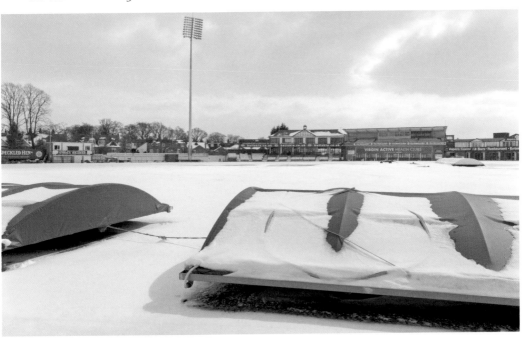

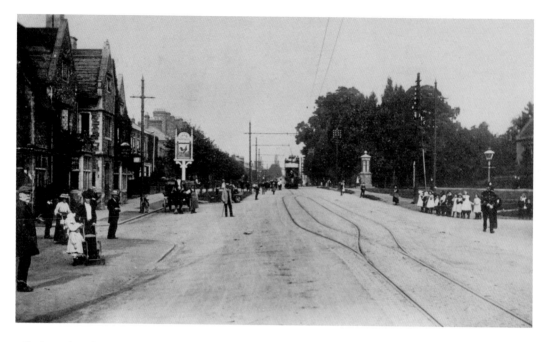

All Aboard at the Cock Hotel

On this view, posted in 1910, crowds gather by the Cock Hotel on the left to catch a tram into town. A stop sign can be seen on the post by the entrance. The current Tudor-style Grade II listed building dates from 1893. A tollgate once stood a short distance away. This remains a busy junction today, but with a constant stream of motor cars rather than tram passengers. The old village of Kingsthorpe is now a suburb of Northampton.

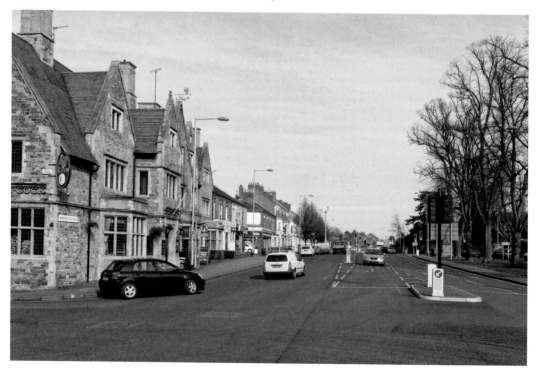

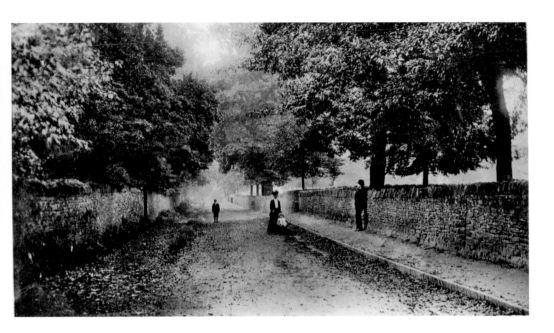

From Lane to Modern Highway

In 1767, Mill Lane, once known as Cock Lane, was a private road from the former Cock Inn to the Nether Mill, popular with walkers. It remained a picturesque country lane until the 1970s. The narrow road, with its sharp bends, led past the old mill site and over the railway to the west side of Northampton and was a bottleneck for traffic before it was replaced by the modern highway. On the green opposite the Cock stands the old tram shelter.

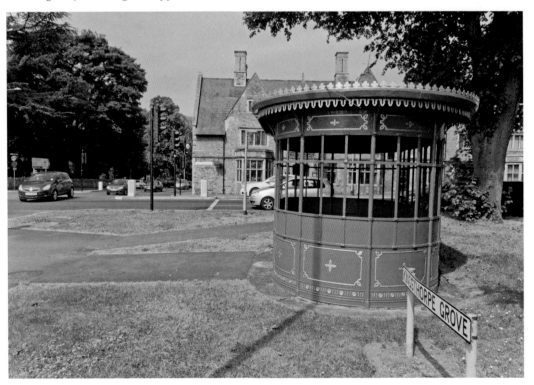

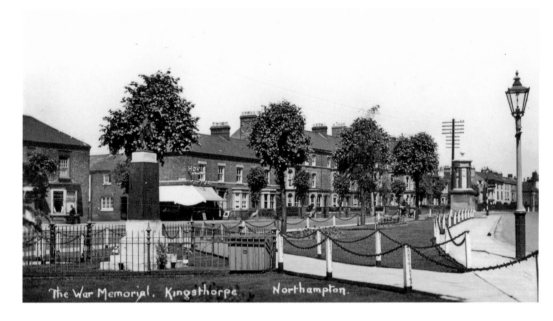

The War Memorial, Kingsthorpe Northampton.

Monuments on Kingsthorpe Upper Green

On the Upper Green by the Cock Hotel stands the memorial to the men of Kingsthorpe and Holy Trinity parishes who died during the First World War. To the north of it on the right is the stone drinking fountain erected in 1897 for Queen Victoria's Diamond Jubilee. The view is virtually the same, though the street furniture has changed from telegraph poles and the lamps to modern electric lighting, and the chained surrounds of the pathway have been removed.

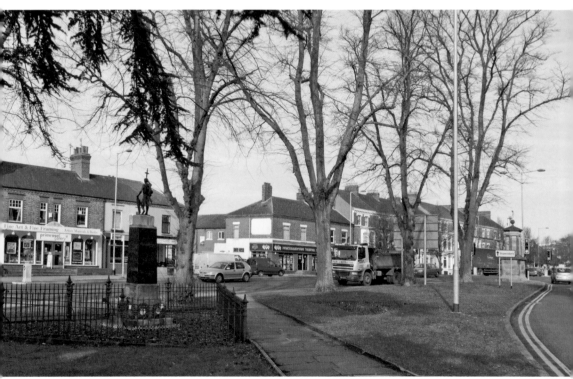

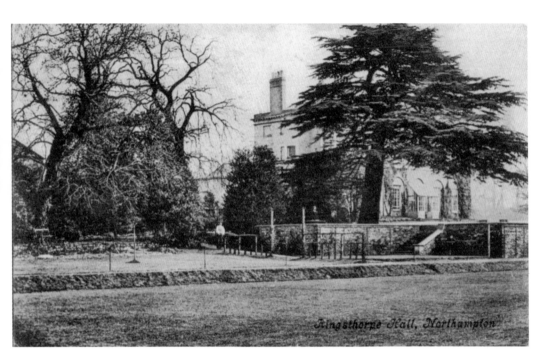

Kingsthorpe Hall and Thornton Park

Faced with white freestone quarried locally, Kingsthorpe Hall was built by James Ferneaux in 1773–75, designed by John Johnson of Leicester, who also built Pitsford Hall. Along with its stables, it is a Grade II listed building. The estate passed to the Thornton family by marriage, hence Thornton Park. The hall now belongs to the community. Its ha-ha had become overgrown, but has recently been cleared by volunteers and work continues to restore the gardens to their former glory.

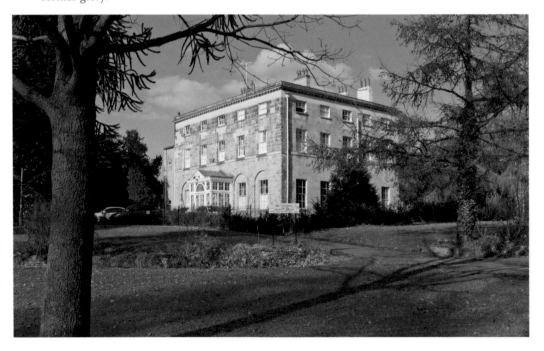

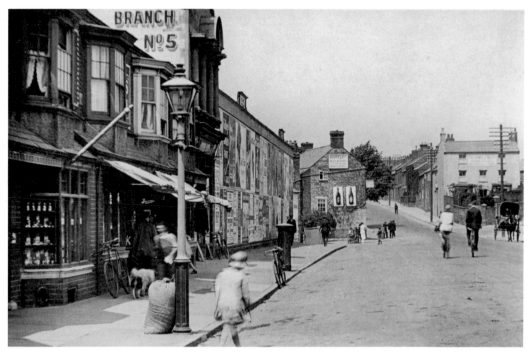

Early Out-of-Town Shopping in Kingsthorpe

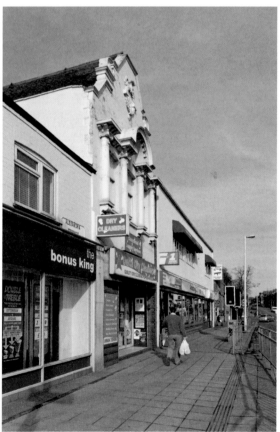

The development of purpose-built shops gathered pace in the early twentieth century and a parade of shops grew up on the Harborough Road, known as Alexandra Terrace. By the lamp-post on the left is a sack outside a corn merchant's, and beyond it Branch 5 of the Co-op, now the dry cleaner's, dominates the scene. The two pubs seen in the distance, the Old Five Bells and the Prince of Wales, are still trading.

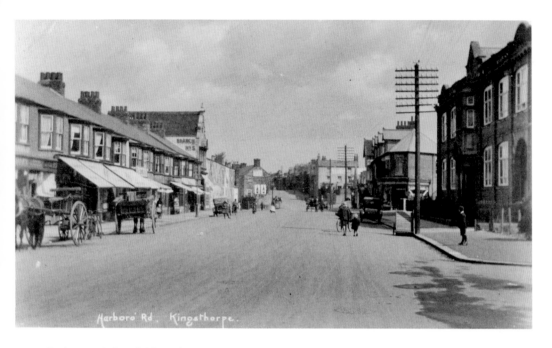

Harboro' Rd. Kingsthorpe.

Harborough Road, Kingsthorpe

This road, now the A508, looks very open on this old postcard, with horses and carts outside the shops and a handcart against the telegraph pole on the right. The motor car was only just coming onto the scene. The junction in the distance leads to High Street on the left and Boughton Green Road on the right, with a public house on each corner. The street is still flanked by shops, but they have a more cosmopolitan look these days.

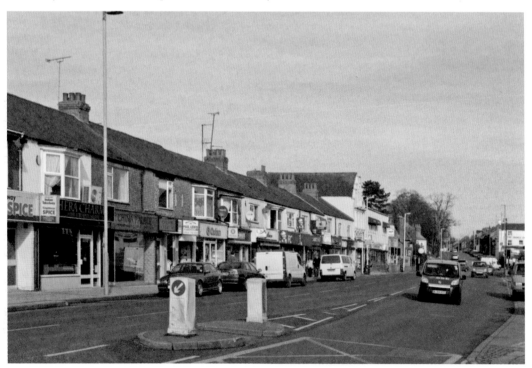

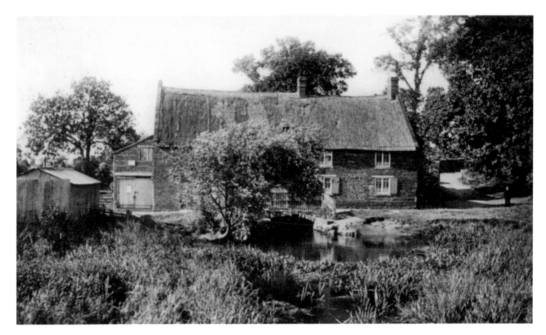

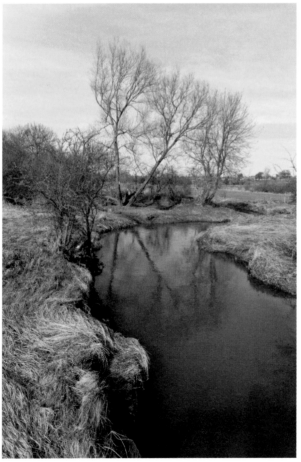

Kingsthorpe's Mills

In the Domesday Book, Kingsthorpe had three watermills valued at £2 3s 4d. The charming Nether Mill on the north side of Mill Lane, seen here on a postcard from 1910, has long since disappeared. The last mention of a miller was in 1898, and in 1900 the millpond and part of the river were converted into a bathing place. The modern road crosses over the site. The route of the river has been changed and it is now a nature reserve, noted for dragonflies and kingfishers.

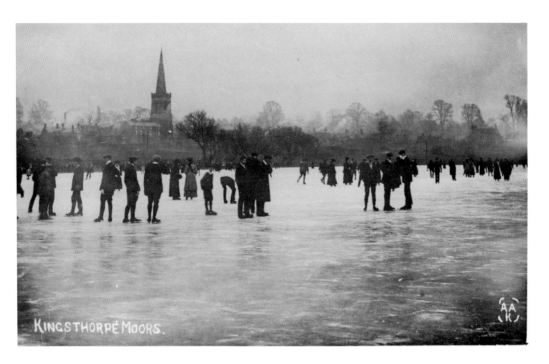

KINGSTHORPE MOORS.

Skating on Kingsthorpe Moors

After ten days of hard frost in February 1912, the Northampton Skating Association dammed the River Nene to flood Kingsthorpe Moors and held speed skating events on the ice. The association ceased in 1914 and was never reformed. This is one of a series of postcards produced by local photographer Arthur Addington of Kingsthorpe. The meadows are now part of a nature reserve, owned by Northampton Borough Council and managed by the Wildlife Trust.

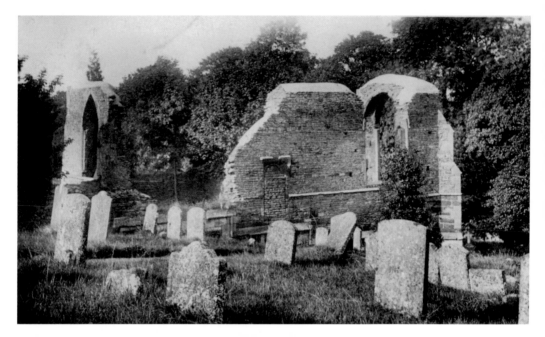

Romantic Ruins by a Saint's Well
Just beyond the east end of St John's
church at Boughton is the sacred
spring of St John the Baptist. First
mentioned in 1202, the church
became disused in the early sixteenth
century. Its fourteenth-century
tower and spire were still standing
in 1773 but have since fallen away.
The churchyard is still used, but has
reverted to nature, having a fine
display of snowdrops in spring and
its ivy-clad ruins attracting many
butterflies in late summer.

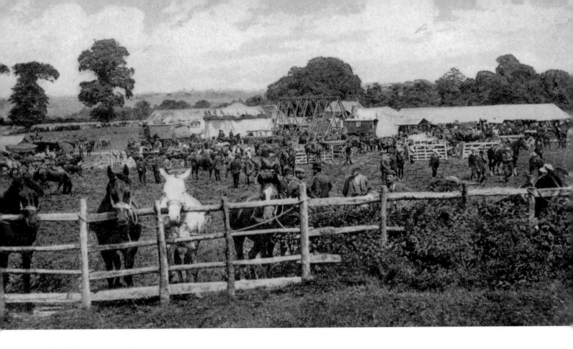

The Fair on the Green
Across the road from the church was the triangular Boughton Green. Now arable land, it was the site of a medieval village before it was deserted in the fifteenth and sixteenth centuries. A fair was granted in 1353 to celebrate John the Baptist's nativity. On the first of its three days, woodcrafts and agricultural implements were sold, followed by festivities with wrestling and horseracing on the second day, and the trading of horses and cattle on the final day.

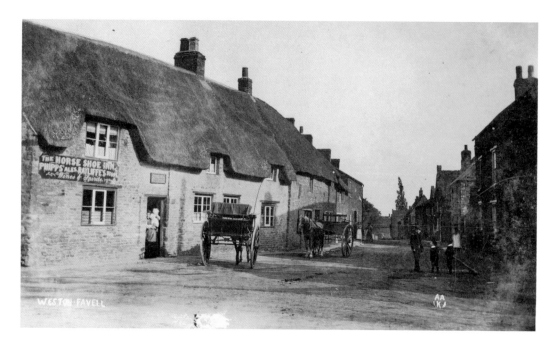

From Village to Town Suburb

The administrative parish of Weston Favell was abolished in 1965 and the village was absorbed within the urban expansion of the County Borough of Northampton. The site of the Horseshoe, originally the Three Horseshoes, a thatched pub on the corner of High Street and Wellingborough Road, lay derelict for many years before Kestrel Close was built in the late 1970s, when the building of the Weston Favell shopping complex created a new growth area for the town.

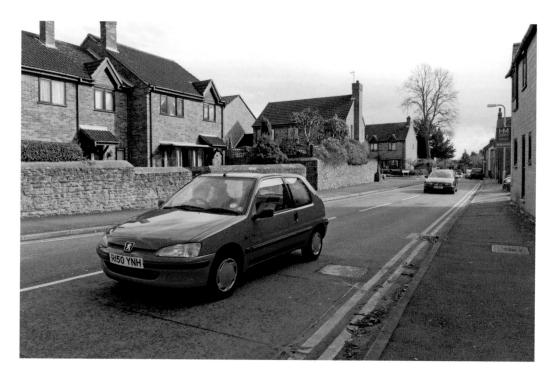

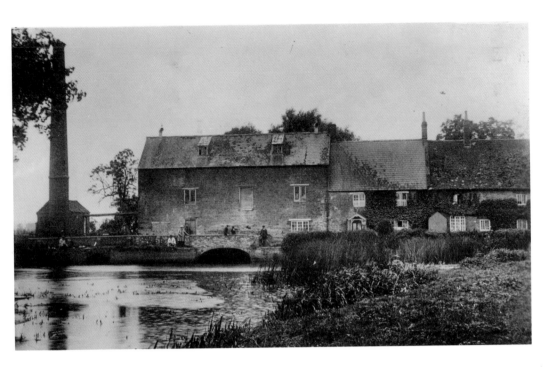

Milling at Weston Favell

Weston Favell had six mills in the 1560s. The building shown here on a postcard from 1922 had a boiler house with a steam engine attached, which was fuelled by coal brought by boat. It also had electric lighting. After being taken over by Joseph Westley, who also leased the Nunn Mills, it fell into disuse in 1938 and is now the marina of Northampton Boat Club. Beyond, lie the Weston Favell lock and the Nene Barrage.

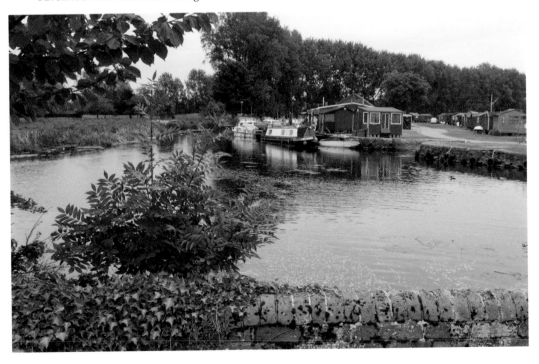

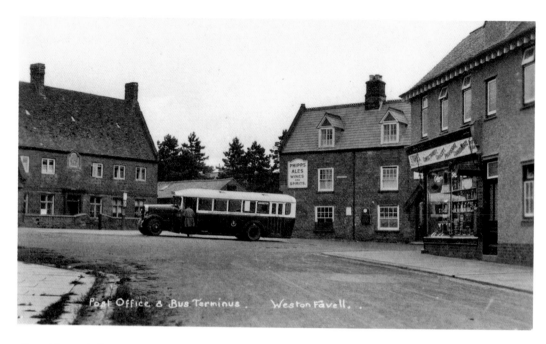

Post Office & Bus Terminus. Weston Favell.

The Old Post Office and Bus Terminus, Weston Favell

Plans to extend tram routes towards Weston Favell did not materialise because of the First World War, but buses served the housing that developed here in the 1920s. A store still survives here but the post office has been closed. The Trumpet, rebuilt in the 1930s, along with the Three Horseshoes, originally took passing trade along the old Northampton to Wellingborough Turnpike. They were on the corners of Church Way and High Street, the two main roads into the village.

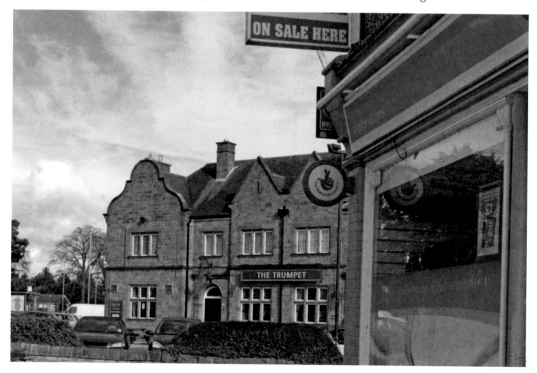

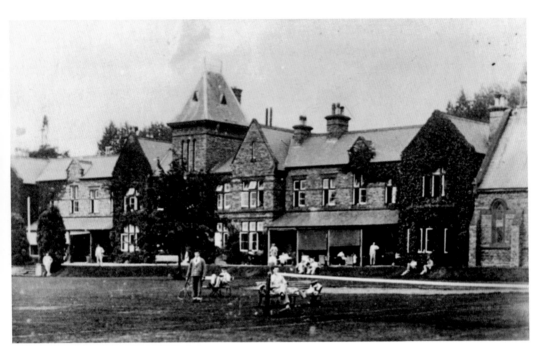

St John's Home, Weston Favell

Surrounded by attractive landscaped grounds, St John's residential care home provides quality care for the elderly, run by St John's Charity, founded in 1138 at the bottom of Bridge Street when it was a medieval almshouse. It was re-established as a convalescent home in 1875 and resited in Weston Favell in 1879. During the First World War, it served as one of several Voluntary Aid Detachment hospitals in the town, and the postcard above dates from that period.

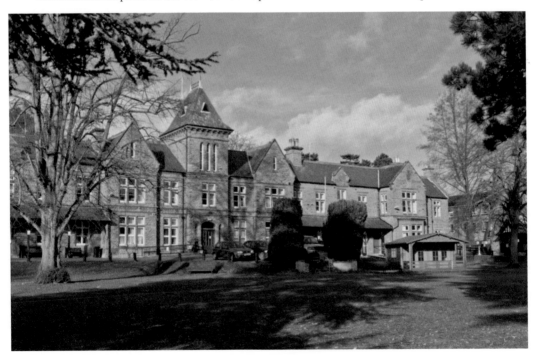

Relaxing in Eastfield Park

Eastfield Park was originally two estates. One belonged to the Manfield family who lived at Weston House, later the Manfield Orthopaedic Hospital. The other was owned by the Ray family who lived at Eastfield House, built next to it in 1924. Major Ray, a former mayor of Northampton, had a man-made lake, which he used for boating. This was fed from a series of smaller lakes known as Lily Ponds, also used for breeding fish. The park is popular with fishermen, and dog-walkers and provides a place of simple relaxation.

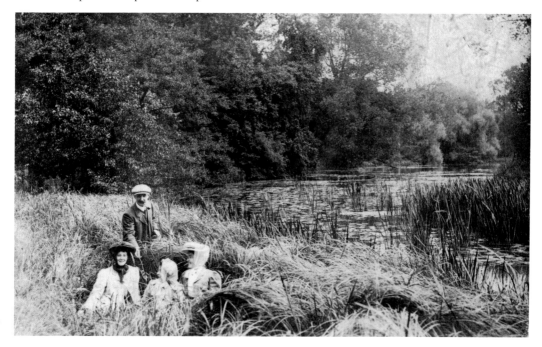